Robin Rhode's art uses the barest of means to comment on urban poverty, the politics of leisure and the commodification of youth culture. The artist has a reputation for brilliantly inventive performances, photography and video animations in which drawing plays a crucial role. In his works, which are often created on the street, Rhode interacts with two-dimensional representations of everyday objects: he draws a candle and attempts to blow it out; he paints a bicycle and tries to ride it. Recently, he has moved towards more abstract forms in paintings and drawings, and has also begun to make sculpture.

Robin Rhode: Who Saw Who is fully illustrated and includes, for the first time, reproductions of Rhode's newest work created at Southbank Centre, London. With an interview with Stephanie Rosenthal and essays by Michele Robecchi and James Sey, *Who Saw Who* provides insight into Rhode's imaginative practice.

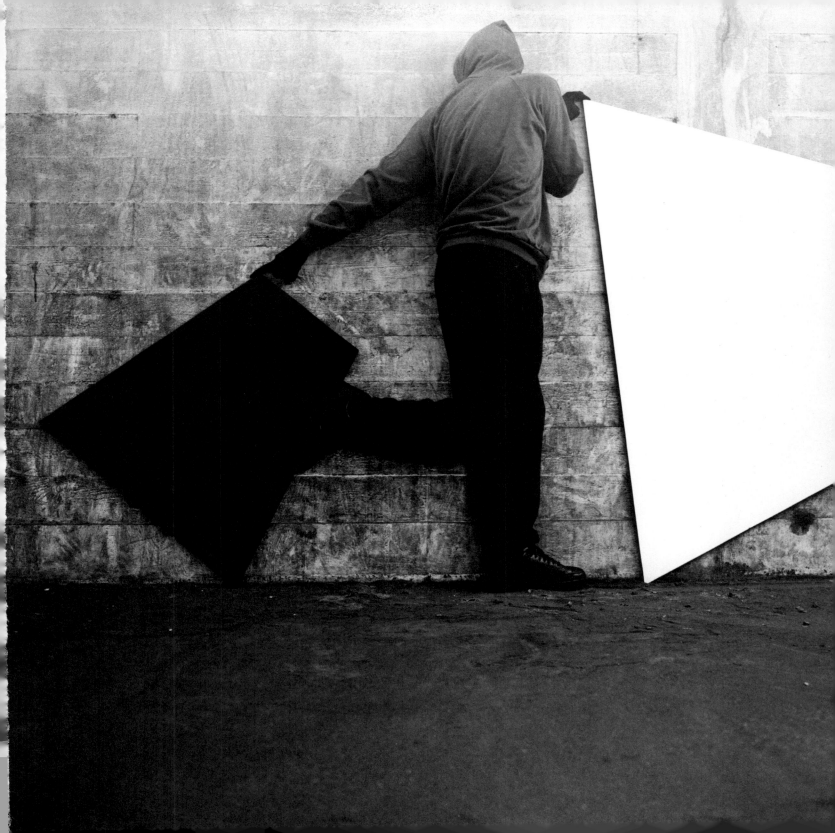

LOTTERY FUNDED

ARTS COUNCIL
ENGLAND

SOUTHBANK
CENTRE

HAYWARD
PUBLISHING

Robin Rhode
Who Saw Who

Contents

Preface

Ralph Rugoff
Director, The Hayward

The Hayward is very pleased to present *Who Saw Who*, Robin Rhode's first comprehensive exhibition in the United Kingdom. In many ways, Rhode's work embodies The Hayward's aspiration to be a cultural test site, a place where visitors encounter fresh ideas about relationships between art, society and popular culture. His exhibition here also reaffirms The Hayward's continuing commitment to showing innovative contemporary art from around the world in ways that resonate with our own particular setting.

Rhode has fashioned a highly distinctive approach to making art over the past ten years. Since his early performances in Johannesburg's streets, which saw the artist acting out theatrical vignettes in response to his own chalk drawings, Rhode has consistently explored the nature of representation, playing with illusion and re-tooling familiar symbols and abstract shapes with a deft conceptual flair. Drawing on music, sports, fashion and cinema, his work probes the tension between the frozen moment of art and the never-ceasing flux of experience. Often making reference to street culture and the gritty realities of everyday life in Johannesburg, Rhode's work – which includes drawings,

photographic sequences, video and sculpture – is also ingeniously inventive in its handling of formal issues and in its playful engagement with the ways we relate to signs, whether personal marks or highly-charged political symbols. Mixing urgency and whimsy, his deft low-fi art manages to transform the barest of means into shrewd meditations on urban poverty, the politics of leisure and the commodification of youth cultures.

There are many people to thank for their contributions to this exhibition. First of all, our gratitude goes to the artist for making the compelling work in the show and for the new photographs (made using the Southbank Centre site as a backdrop) that are presented for the first time in this book.

Thanks also go to Hayward Chief Curator Stephanie Rosenthal, who has done a brilliant job organising this exhibition, working in close collaboration with the artist in selecting key works from his career and in commissioning new works. Rosenthal's penetrating insight, acute sensitivity and remarkable ability to grasp the heart of an artist's work have helped make this a very special exhibition. She has been ably assisted in her work on this show by Dana Andrew and Chelsea Fitzgerald. Imogen Winter and Mark King have brought their distinctive skills to the installation of the show.

We are grateful to the authors of this catalogue – Michele Robecchi and James Sey – for their insightful texts, as we are to Adam Hooper for designing the book, which is so empathetic with Robin Rhode's oeuvre. We are also grateful to Caroline Wetherilt and Giselle Osborne of Hayward Publishing, who have invested their characteristic professionalism to the production and editing of this publication.

Our thanks also go to Fatima Maleki, who was kind enough to lend assistance to make this show happen, and to Andrée and Howard Shore. Furthermore, we would like to thank Perry Rubenstein and the director of his gallery, Caroline Dowling, for their endless support, as well as White Cube, here in London, for being so attentive. Last but not least, the show could not have happened without the generous support of our lenders: Shawn Carter, Matthew Fitzmaurice, Goetz Collection, Hall Collection, Michael and Fiona King, Perry Rubenstein, Sender Collection and White Cube.

Introduction

Stephanie Rosenthal
Chief Curator, The Hayward

Robin Rhode's art starts with himself and a piece of chalk. He draws a candle and tries to blow it out; he sketches a bicycle and tries to push it away; he sits at a white wall and plays painted drums. Connecting drawing and performance is his thing.

Born in Cape Town in 1976, Rhode moved to Johannesburg in 1984, where he studied art from 1995 to 1998, and film later on. Since 2002, Rhode has lived mainly in Berlin, but to this day Johannesburg has remained his main creative inspiration. The city is both the 'stage' and 'canvas' for his works. In 1997, Rhode started to interact with his chalk drawings of objects on walls and floors. Then, as now, his performances have often been spontaneous actions that have just 'happened'.

The root and ever-new departure point for his work is drawing: making marks, drawing with his own body in space, creating drawings with chalk and paint on the floor, on a wall, on paper. Drawing always stands for itself, but is also (or represents) a counterpoint to his performances. Rhode appropriates external surfaces, be it a section of wall, a courtyard or a riverbed. The protagonist is the human body – his own and/or, since about 1999, his doppelganger's.

The walls and the floors that Rhode chooses for his drawings are never just neutral backgrounds. They contribute their own history, nature, textures and colours, and are crucial to the composition. For *Who Saw Who* at The Hayward, Rhode has turned the Southbank Centre site into his canvas, leaving white chalk drawings on the concrete walls. For the first time, he has interacted with geometric wooden shapes; he himself has become form and has turned the spotlight on abstraction.

Rhode's strength is his spontaneity, his ability to make his mark, to bring objects and abstract forms to life. His performances live on in photographs and animations. Even the sculptures and paintings he has been making recently could be described as spontaneous. Here, too, he is driven by the ephemeral – not the eternal. A soap bike on an exposed terrace is destined to disappear; charcoal and chalk shells disintegrate as the artist draws.

Rhode makes art that is creative, out of determination, not whimsy. Like Sisyphus, he never forgets the sheer weight of the reality that he has to push up the hill. In all of his works, he manhandles this knowledge like a light-footed clown with gigantic shoes.

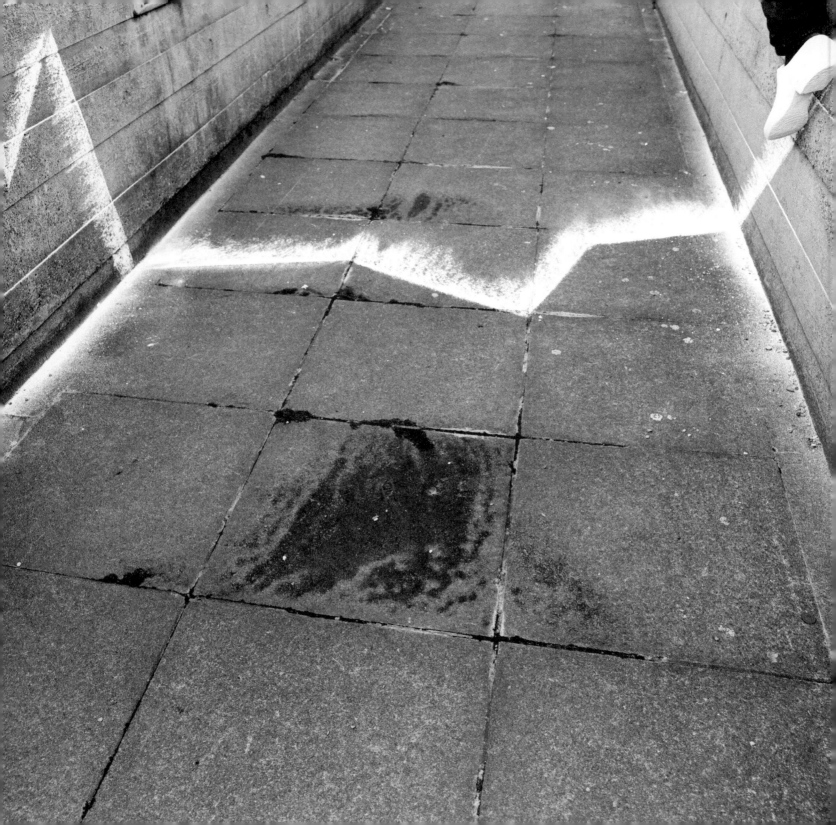

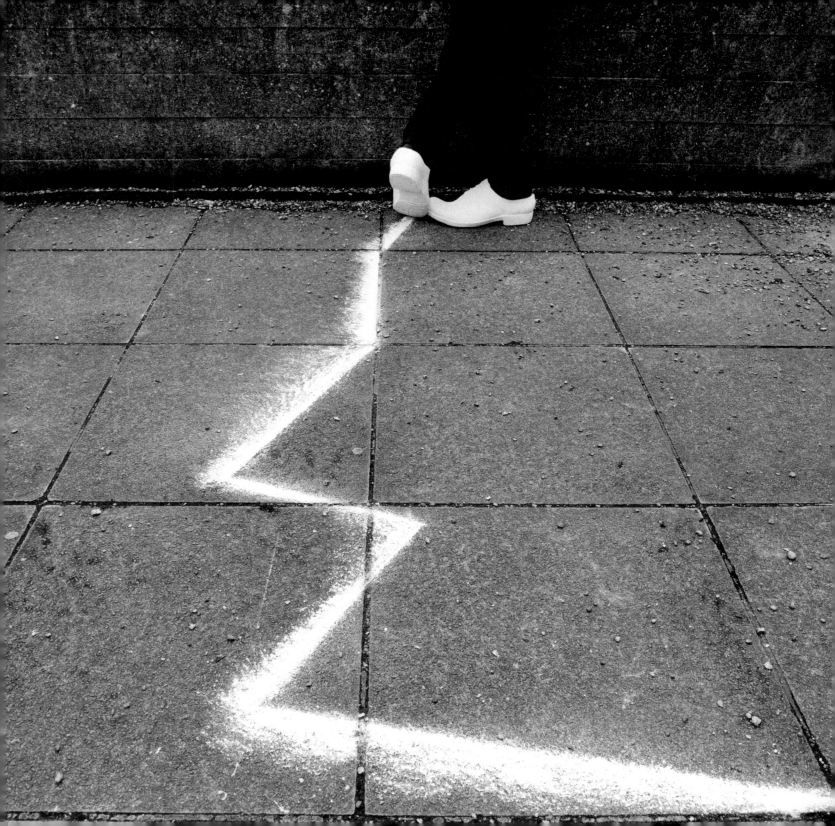

Jozi Juice
James Sey

'Everyday life invents itself by poaching in countless ways on the property of others.'[1] Michel de Certeau

Jozi, The City of Gold

Approached from both east and west, Johannesburg (a.k.a. Jozi), the City of Gold, presents a lyrically beautiful cityscape; nestling between ridges and flanked by dumps of gold mine effluvium that have grown into the landscape as hills, it rises up as a characteristic vista. There are the 50 stories of the Carlton Centre alongside, in this long view, the Brixton Tower, still broadcasting signals. Over there, the outline of new construction, cranes gracefully picked out in relief against the sky as the World Cup 2010 stadiums take shape. The serrated edges of the city's skyscraper profile, framed by highway overpasses and the natural landscape, are hung here and there with Christo-like, building-sized advertising drapery, recognisable as one draws nearer. Gradually, another city looms up – murder capital of the world, walled-in suburbs, rampant gun crime, drug-running, prostitution, homelessness, AIDS, poverty, money, energy, art. Welcome to Jozi.

Ambivalent City

Every city is an ambivalent organisation. Alongside its readable structure – the mappable territory that has been planned in advance, that shapes and arranges – lies the other structure of contingency – the city that has been created by its users and inhabitants. This type of city evokes, determines and produces behaviours, styles, attitudes, values, pathologies. Each city, therefore, has at least a double character, and a double narrative, and its inhabitants play many roles within them. The surfaces and depths of the city's structure, its being – from the towering replications of its skyscrapers, to the hollow aortas of its covered car parks, to the secret somatics of its circulatory systems of tar, wire, cable and pipe – all form a paradigmatic sign system, a *primary cybernetic machine*. Seen as such a sign system, the city should be the true locus of modern aesthetic philosophy.

Cities are sites of great novelty, innovation and overload. The early avant-gardes and the great *litterateurs* of the industrial era focused on the city as a field of possibility, inextricable from the technologies and sites that enabled those possibilities – traffic, advertising, cinemas, factories, empty walls, concrete underpasses. Urban aesthetic tactics are exemplified by Michel de Certeau's famous essay 'Walking in the City', where the city's inhabitants find their own routes, their own street plans, which have a multitude of meanings for them.

There is no conscious, ideologised, 'us versus them' scenario in the dynamics of the city. Urban artists work in a plethora of modes, using the city to produce discourse and refine practices in many different subcultures. Music has a role, with all of the languages, loyalties, spaces and fashion it provides. Beyond music, the city has its own soundscapes, white noise and birdcalls, traffic and sirens, an undifferentiated mass of machine noise. There are sports, from street football, basketball and skateboarding to free running and base jumping. The city is also saturated with visual representation – from billboards and magazine covers to the endless graffiti that manifests as a signature urban aesthetic style – sprayed on the canvas that the city's walls mutely provide. What these urban discourses have in common is their quicksilver mutability, their existence as a set of subversions of the city's planned and formal character.

Robin Rhode and Jozi's Palimpsests

It is in this interstitial space between the planned and visible nature of the city, and its street level cultures and practices, that Robin Rhode's work takes root. In particular, it takes root in the streets of Jozi. Rhode's work is tied to the DNA of this city, a city that constantly renews itself, that constantly forgets its own history of colonialism, gold mining, apartheid and hard-faced struggle. Many different kinds of wars have been fought on the streets of Jozi, the most recent being the most ironic – the xenophobic attacks against migrant workers from other African countries. The attacks are ironic because the inhabitants of Jozi were once migrant workers themselves, who created the city – literally built it – as its cheap labour for the gold mines that surround it.

The Jozi that Rhode moved to as an eight-year-old child in 1984, from his birthplace in Cape Town, was on the brink of radical transformation. As South Africa's biggest city and its financial capital, Jozi is one of the finest examples anywhere in the world of the mutability of cities, their propensity for change and reorientation. Since the demise of institutional apartheid in 1990 and the advent of the democratic African National Congress-led government in 1994 – just a few years before Rhode began his art career in 1997 – the city has been subject to a process of constant physical and ideological 'renewal' in order to try to change its older character, which exemplifies apartheid architecture and racial inequality.

While the general programme of renewal has been driven by an unimpeachable ideological agenda to make the city more inclusive and representative, the urban planners have run into the dilemma of the ambivalent character of the city in modernity – the way in which it is defined by, and yet resists, urban planning and governance. The renewal process in Jozi is full of anomalies: historical buildings have been torn down to make way for gleaming and anodyne new office blocks, but their nineteenth-century facades have been retained in a nod to historical respect. An apartheid era prison on top of one of Johannesburg's many ridges, and which once incarcerated both Gandhi and Nelson Mandela, is now an art gallery and museum. It is also the site of the groundbreaking building that houses the new Constitutional Court.

One could argue, therefore, that the key aesthetic manoeuvre of Jozi is the *palimpsest,* the writing or drawing over onto

another set of images, texts or meanings. The city, we should remember, is a giant circulatory system. It recycles things, including water and air. Images and meanings are not exempt – new billboard images replace yesterday's product, today's headlines usurp yesterday's. There's a continuous *palimpsestuous* circulation of urban meaning: noises on top of each other, fashions colliding and stealing from each other, skateboarders turning banisters into grind rails – a part of their own urban geography. And there is more than just meaning and representation at stake; there is a reason why Jozi is among the most dangerous and criminal cities in the world. Territories are protected here with deadly force, by suburban homeowner, housebreaker and carjacker alike. And even the graffiti artists are packing a blade or a gun along with the spray cans in their backpacks.

It is these aspects of the city's secret and most edgy areas that Rhode understands best, where he situates the motive force of his drawings, animations, photographs and films. And, of course, his work is itself palimpsestuous – a drawing and redrawing, as smudged lines and ludic tracery on the city's surfaces. Although Rhode has lived in Berlin since 2002,

he returns to those Jozi streets to soak up that emotion, and to use the walls of Jozi still, which were his first canvases, even though the maturing trajectories of his work have diversified into different areas – notably sculpture and painting. As Rhode puts it in a recent conversation with the artist William Kentridge in the magazine *Modern Painters*, 'I have to return to South Africa to get in touch with the spirit again. I rely on this spirit, coming back, working on these streets…'[2]

City of Art?

The fractured edginess of Jozi as a site for contemporary art and artists is born of its troubled history. The 1980s saw the beginnings of what might be called a contemporary art 'movement' in Jozi, led by luminaries such as Kentridge and Robert Hodgins, and younger artists like Deborah Bell and Kendell Geers, the latter of whom would have a major influence on the young Rhode. But, Kentridge apart, few of this generation of artists took part in any international currents or exhibited outside of the tiny handful of contemporary galleries in the city. The country was in the grip of a self-obsessed struggle against the radical isolationism

and vicious repression of arts and culture that marked the apartheid regime in its last days.

With the coming of liberation – and the advent of the internet – in the 1990s, the Jozi art scene changed fairly quickly. A new generation of artists could finally see a career in art as a reality, and were unrestricted in their movement and communication. Many of this generation combined art making with careers in criticism and curation as new possibilities opened up. Early influences on Rhode's career in Jozi such as Kathryn Smith and Stephen Hobbs, co-founders of art collective The Trinity Session, were among this wave of artists, and were responsible for introducing Rhode's first performances to the art world in Jozi and South Africa. Others in this network of young contemporary artists included video artists Tracey Rose and Moshekwa Langa.

Jozi has not always been a forgiving or welcoming place to be an artist, though most of the country's corporate collections are housed there, as well as a growing network of contemporary galleries. At the time of Rhode's decision to leave the city, and the country, for Berlin in 2002, its energy was very much on its streets and clubs rather than its galleries.

Capturing and transforming that energy is, in an important sense, what Rhode's work has always been about.

This is not a Wall

At times, Rhode's work has fallen squarely into a performance and art-historical tradition, as with his early work *Leak* (2000), in which he drew a urinal in charcoal on the wall of the SA National Gallery in Cape Town, and then actually pissed in/on it. The references to Fluxus, the Happenings strain of performance art and to Marcel Duchamp's 1917 foundational intervention, *Fountain*, are all unmistakable. By now, well-known works, in which the artist or his doppelganger attempt to interact with a two-dimensional representation, include *He Got Game* (2002), a storyboarded photographic series shot from above in which the artist makes an impossible slam dunk into a basketball hoop chalked on the ground. There is also *Stone Flag* (2004, pp. 40–41), a similarly staged piece in which a white-suited and floppy-hatted figure waves a flag composed of red bricks – a sly allusion, perhaps, to the Russian Constructivists and their aesthetic attempts to keep the red flag flying. Constructivist graffiti and poster art

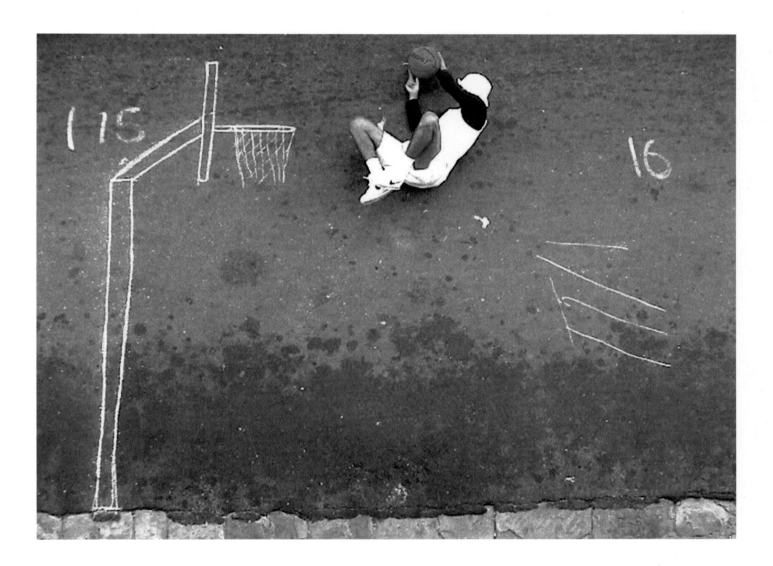

He Got Game [2002]

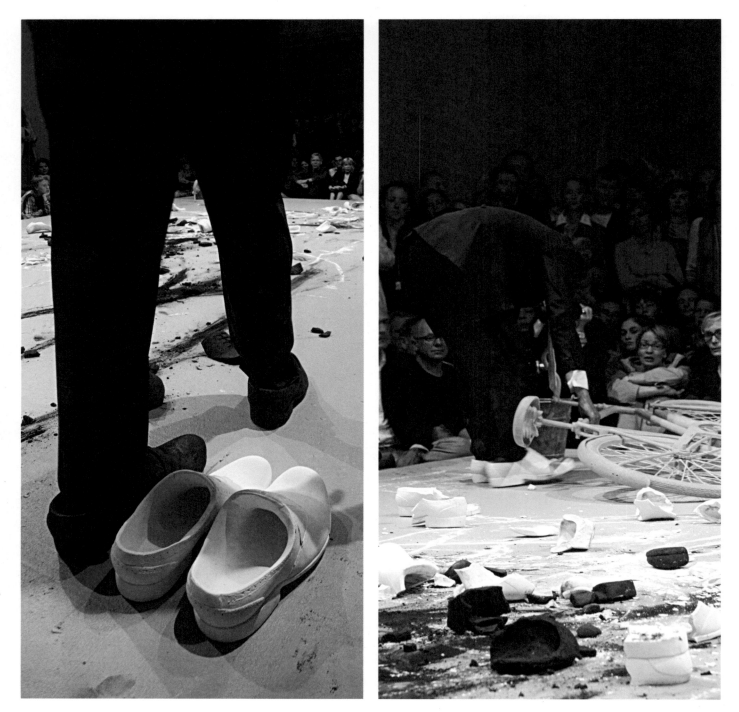

adorned much of revolutionary Jozi during the 1980s and 1990s, including areas of the city in which Rhode drew and photographed his work. In *New Kids on the Bike* (2002, pp. 28–29), the young bike riders cling on for the ride of their life in an expiation of the schoolyard bullies of Rhode's youth, who subjected him to ridicule by making him do exactly this kind of make-believe in the school playground.

The interplay in these works between two and three dimensions is a key aspect of Rhode's aesthetic. The interaction of the performing body and the marked surface of the city wall or its asphalt is the device that unlocks the ludic power that Rhode draws from the urban landscape. Inserting this into the gallery space can bring an unwelcome sterility to the interaction, and can lead to expectations of a certain type of aesthetic intervention.

In the performance that accompanied his 2007 Haus der Kunst solo show, *Frequency,* in Munich, Rhode had a dancer put on various shoes he had sculpted from white chalk and black charcoal and wear them as he ventured out over a prepared section of the floor, thus generating a drawing. As Rhode puts it in the *Modern Painters* article:

'[The work is always] against the wall. But with performance and theatre, *here* is the wall. And the wall collapses. It's like my Munich piece. I sculpted shoes in chalk, and a dancer put on the shoes and moved, making a drawing across the floor. People asked me, "why aren't you using the wall?". But the wall had collapsed – he was drawing on that surface.'[3] From this basic unit of his art – call it 'performative drawing' – Rhode has extended his repertoire and palette into film, animations and now sculpture and painting. But this essential circuit remains – drawing, the city's walls and an interplay of spatial dimensions. His spiritual home, Jozi, is an equally essential element in this circuit, for its personal resonances for the artist as well as its hardcore urban character. As he writes:

'With regards to my photographic works, over the last three years or so I have [mostly] stopped creating photo works in other parts of the world. Europe is too defined. Too clean, too safe. I now work [mainly] on the streets of Jozi … most recently in a location in Brixton amongst squatters and homeless [people]. I work unannounced with no contacts to South African institutions or galleries. My street works are self produced.'[4]

Brixton in Jozi has much in common with its London counterpart. It is a hard and mean-streets inner-city suburb and is characterised by street vendors, squatters in ramshackle houses, drug running and, at its edge as it rises over one of the city's many ridges, spectacular views to the horizon – a classic Jozi contradiction.

Monument to the Chairman (2008) is a work that, according to Rhode, is inspired by this location.[5] In a nod to Vladimir Tatlin's *Monument to the Third International* (1919–20), a stencil of a chess pawn is built up as a game played by one figure in a white top hat and an opponent in a black one. The accumulation of marks as the moves build up, the use of the city wall and the graffitist's stencil, and the reference to a game, albeit a more rarefied one than the street sports of his earlier work, all mark the piece as classic Rhode. The final image is indeed monumental, yet playful; permanent in its gravitas. The viewer also recognises the ephemerality of the 'monument', its transience as the wall will be painted over.

In the animation and print series *Empty Pockets* (2008, pp. 106–107), which was also realised in this inner city area, the typical Jozi pastime of outdoor pool, or billiards, is referenced.

In the animation, the upside-down pool player seems to defy gravity as the balls float in mid-air, seemingly drawn back to the table as if the three dimensions need to revert once more to two. The photographic work re-emphasises the artist's mastery of this interplay, with the table providing a stable reference point in a game that disorients the viewer. Other works, such as *Catch Air* (2003, pp. 32–33) and *Night Boarding* (2004), though not tied to this particular location, speak of the same themes – the opening up of another dimension of the drawing through the physical intervention of the figure in the two-dimensional work performing a typically urban activity, in this case, skateboarding.

In *Blackhead* (2006, pp. 66–67), a surrealist tableau is acted out as a figure with no head connects with a series of stylised disc-figures on the wall, substituting its head, and eventually walking out of the frame, leaving only an evocative line of smudged shapes suggesting the figure's presence. Photographic works such as *Blackhead* were realised in the Newtown area of Jozi, once an industrial manufacturing site and railway siding for the nearby markets. As Rhode himself mentions, even this area has become too sanitised to carry the

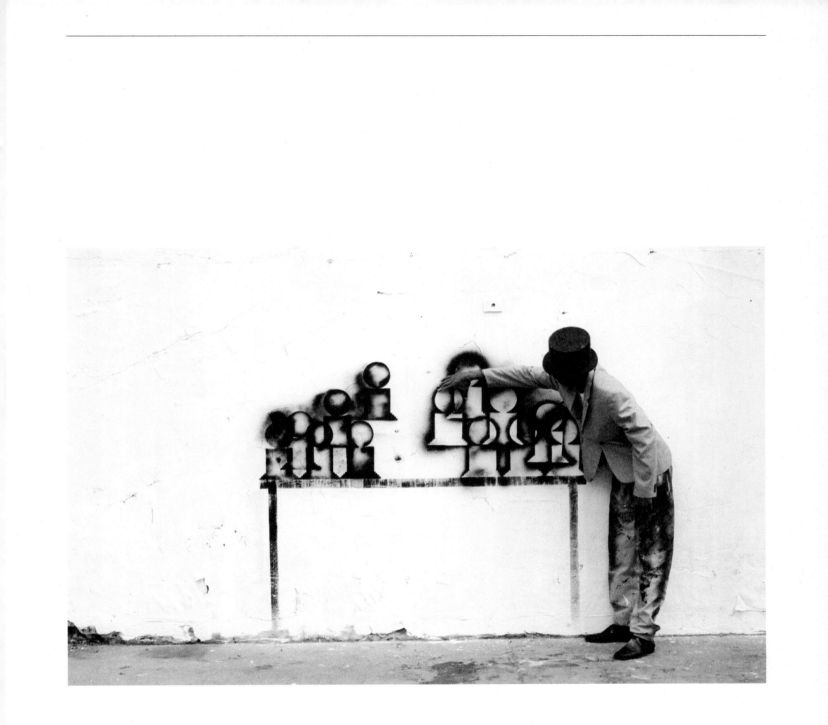

Monument to the Chairman [2008]

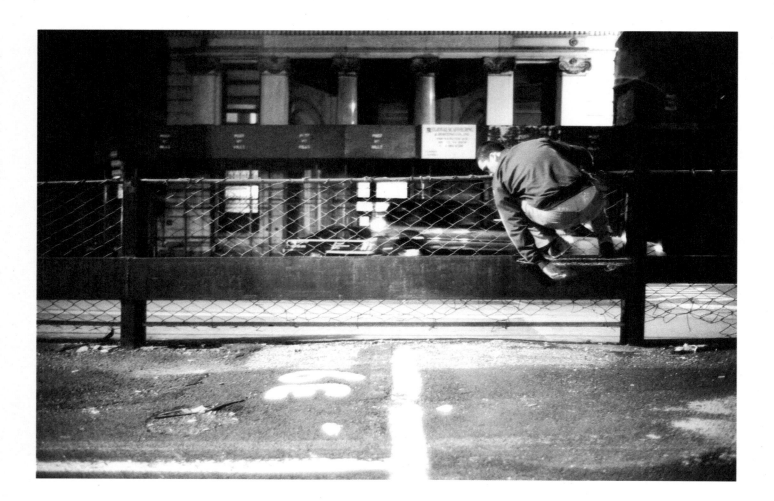

Night Boarding [2004]

charge of the city the frame of his works demands. However, the ironies and ambivalences of the city are well expressed by this area. The setting aside of a cultural 'precinct', the Newtown Cultural Precinct, alongside the site of the most famous anti-apartheid theatre complex in the world, the Market Theatre, shows the urban planners' dilemma of attempting to legislate art – it remains largely dormant and underused. To the north is Museum Africa, the site of part of the Johannesburg Biennale in 1997, which Rhode has cited as a key influence on his artistic development.

Inside and Outside the Frame

Though it does not condition the work itself, the specificity of place is vital for Rhode. The liminal and dangerous nature of much of Jozi's inner city, its day-to-day vitality and uncertainty, provides a real urban context that is not transferable or substitutable. As he puts it:

'Even though the frame of the work is autonomous in that the viewer cannot completely pinpoint the geographical location, the feeling of fear and uncertainty affects the working process completely. These inner city walls become my backdrop or stage on which to project my narratives. The feeling I have for the sites are unique, therefore I have conditioned myself to working anonymously on the Jozi streets.'[6]

The essence of his work – the performative drawing, the surrealist and ludic nature of his narratives, the hip urban reference points – are all determined by the idea of the street. And not just any street – the streets of Jozi give Rhode the juice to enact his own theatre there, to go beyond the live performances that marked his earlier work, and to build his own narrative urban netherworld, an Every City that is always already Jozi.

Notes

1 Marcel De Certeau, *The Practice of Everyday Life,* University of California Press, Berkeley, 1984.

2 Quoted in *Modern Painters*, June 2008, p. 66.

3 Ibid, p. 67.

4 Email to the author, June 2008

5 Ibid.

6 Ibid.

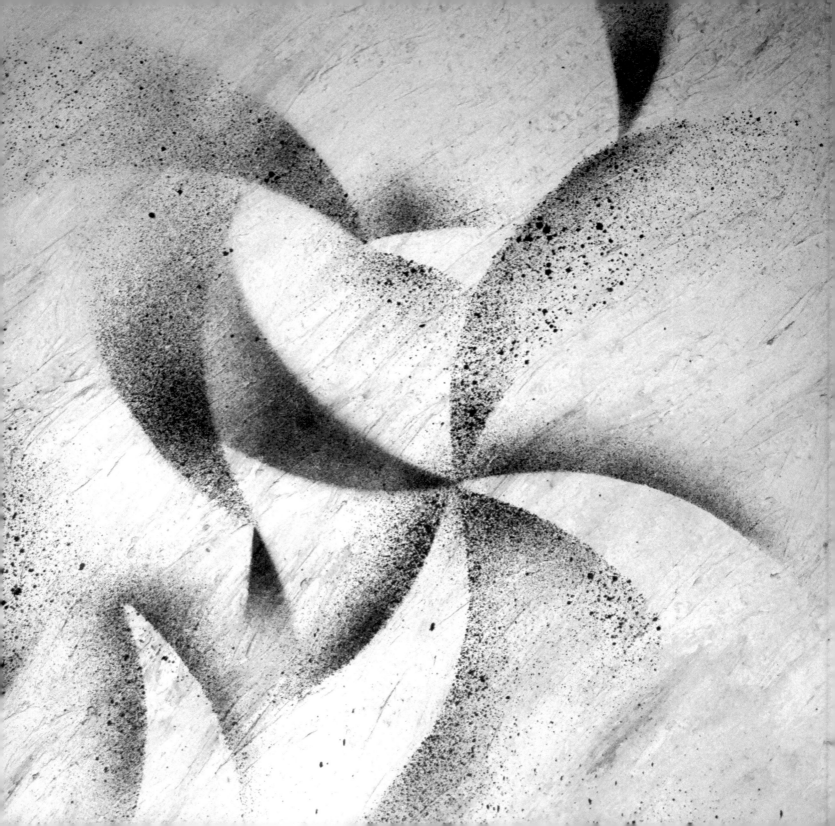

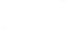

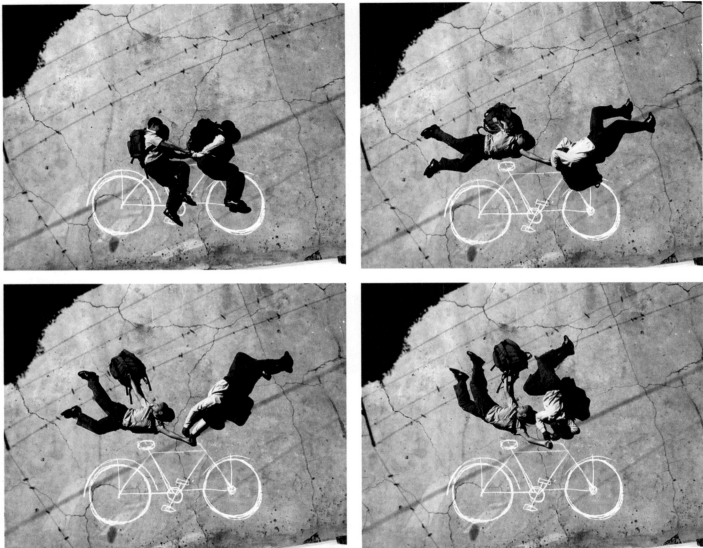

New Kids on the Bike [2002]

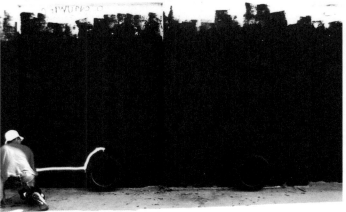
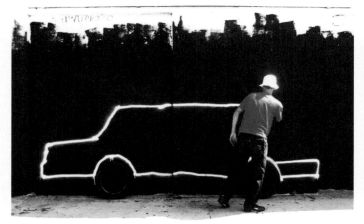
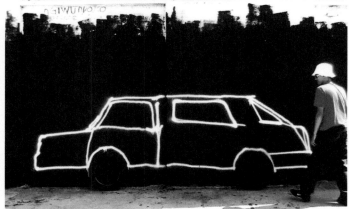
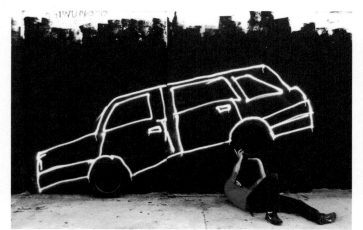
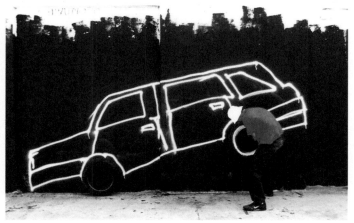

White Walls [2002]

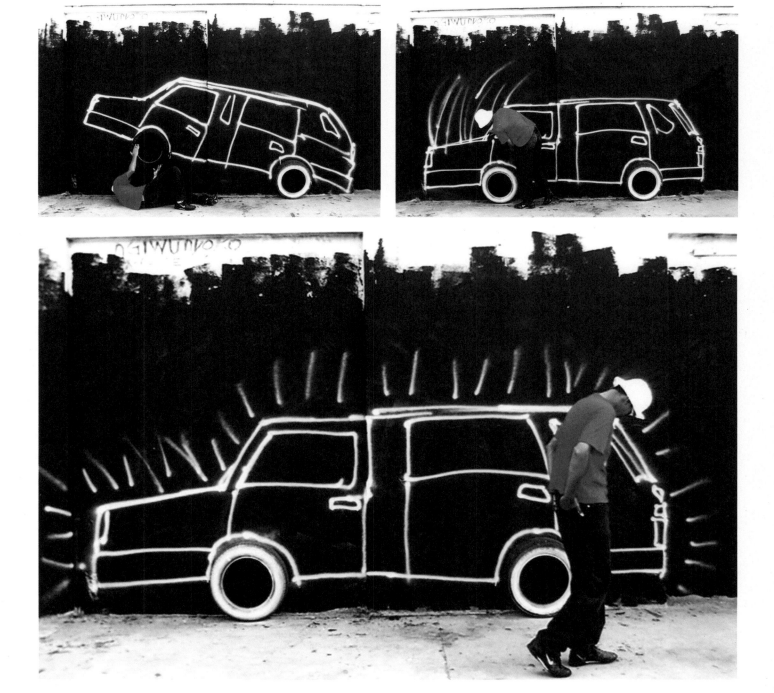

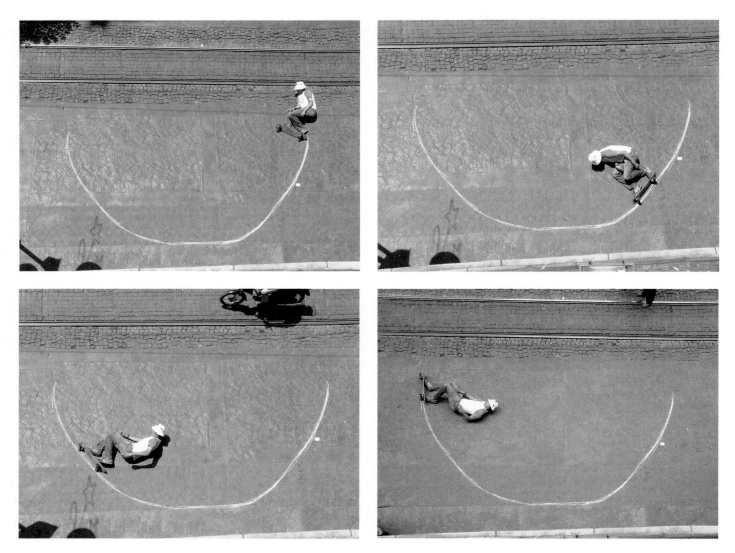

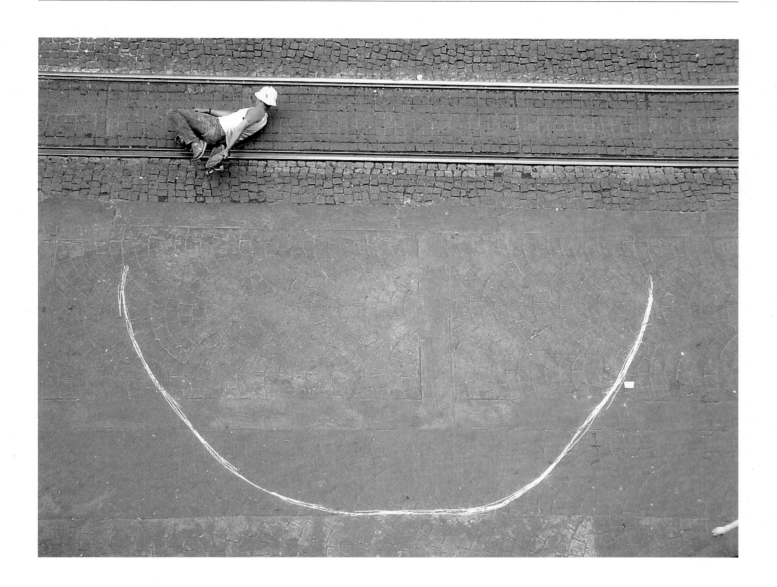

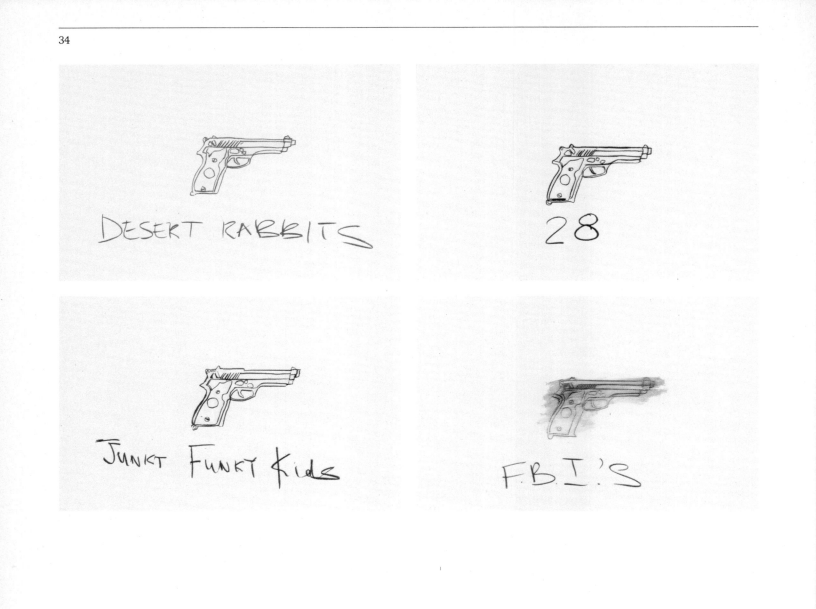

DESERT RABBITS

28

JUNKY FUNKY Kids

F.B.I.'S

THE AMERICANS

SCULPTURE

UNTITLED

THE HARD LIVING

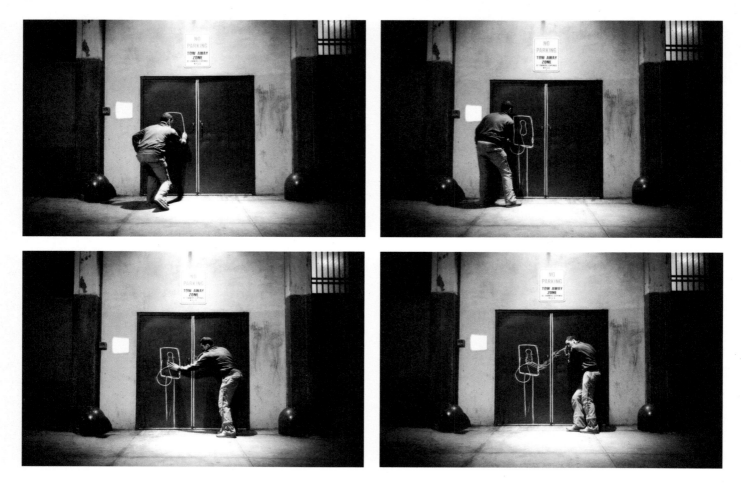

Night Caller [2004]

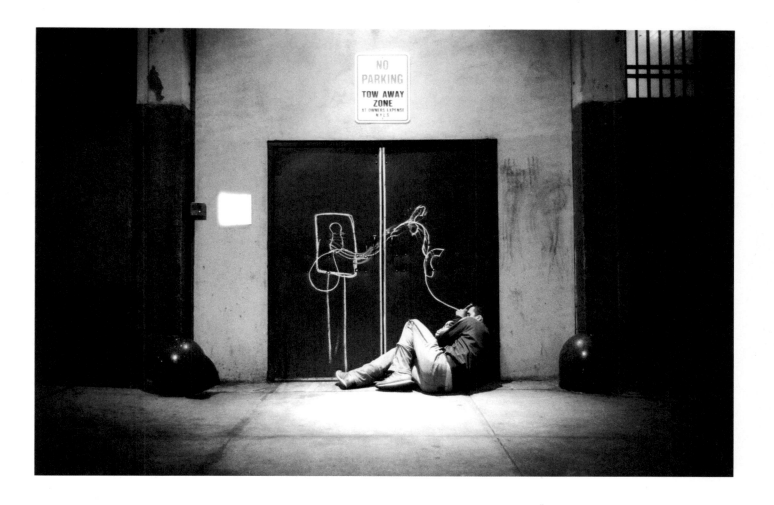

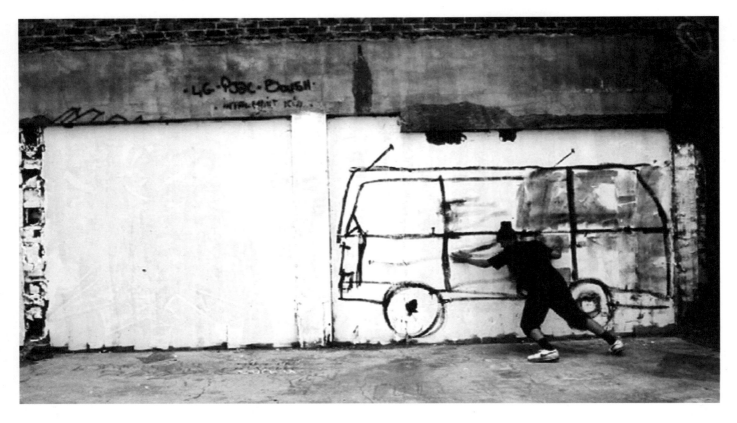

The Stripper [2004]

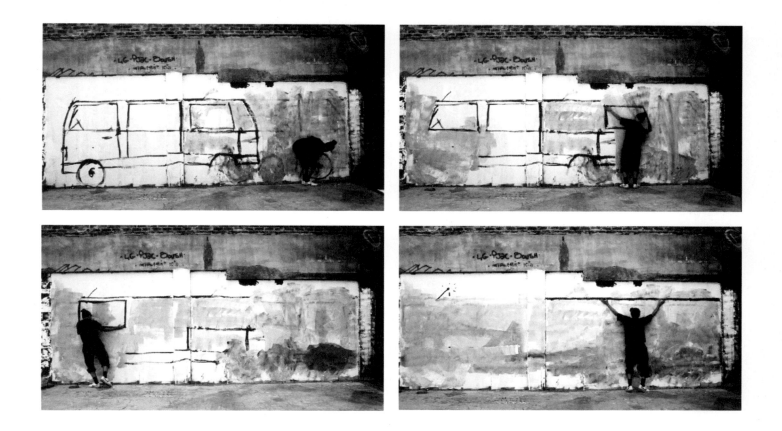

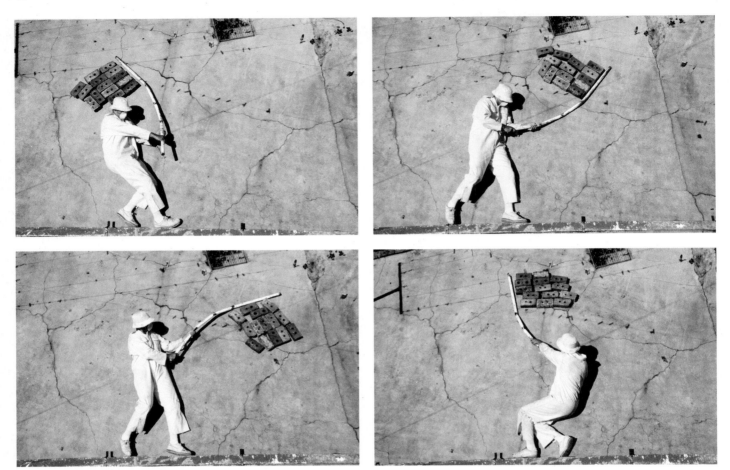

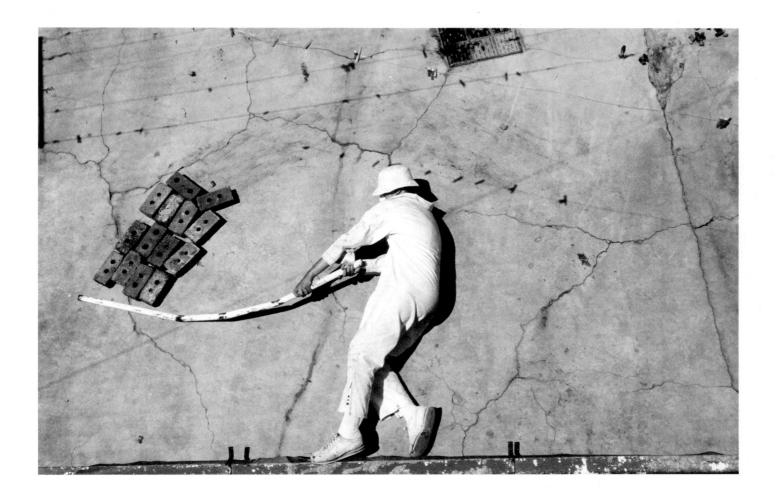

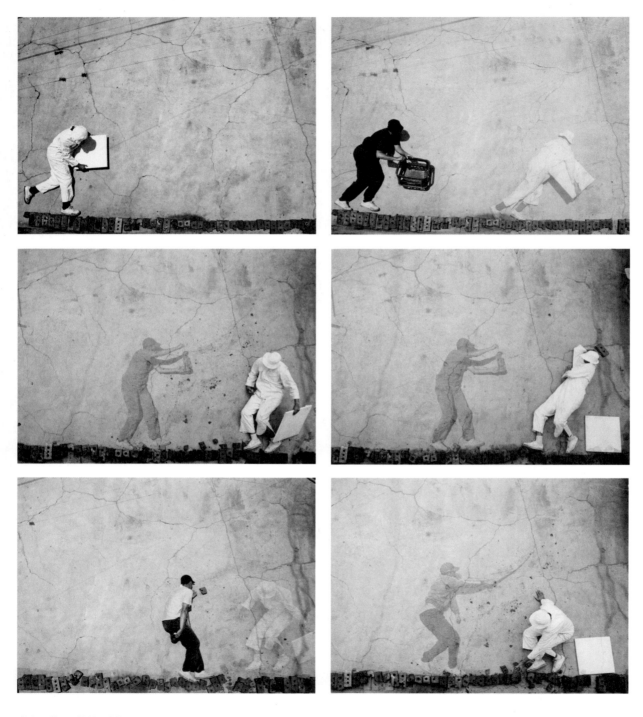

Color Chart [2004–06]

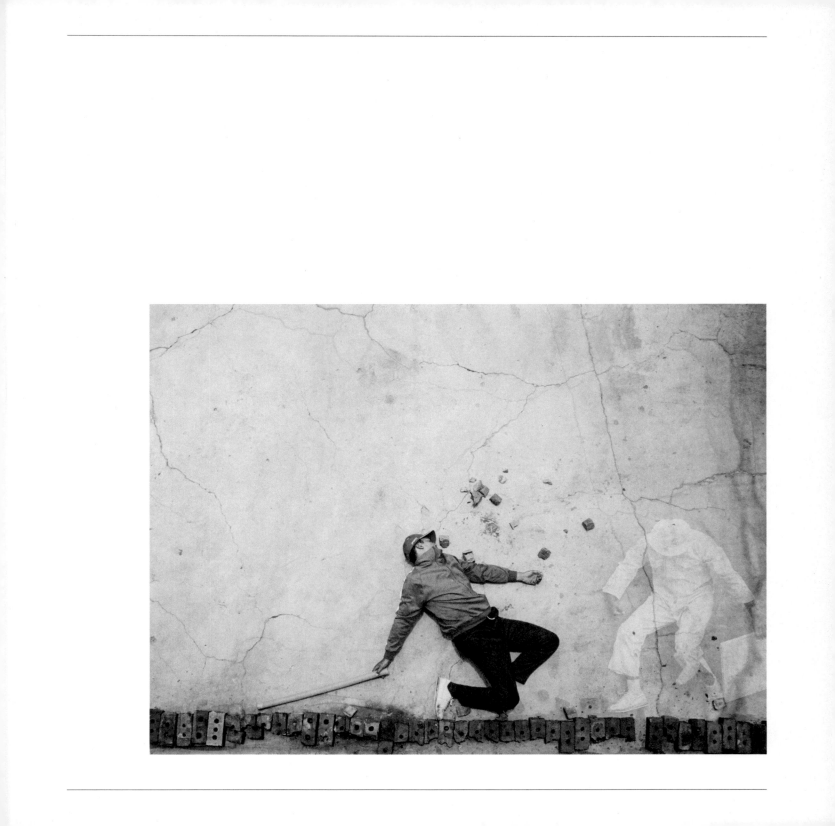

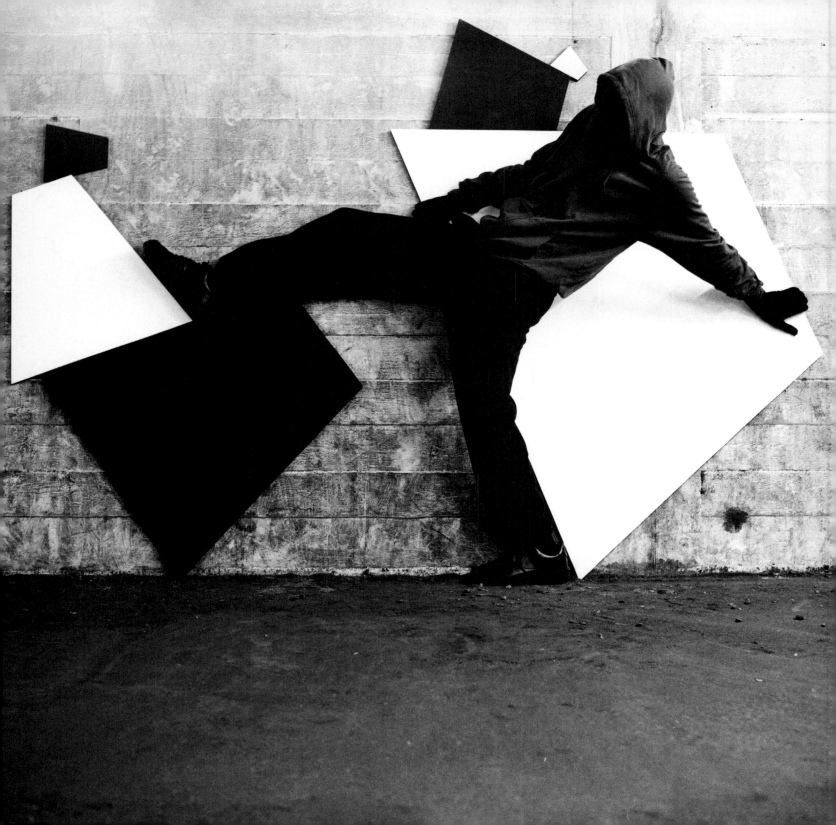

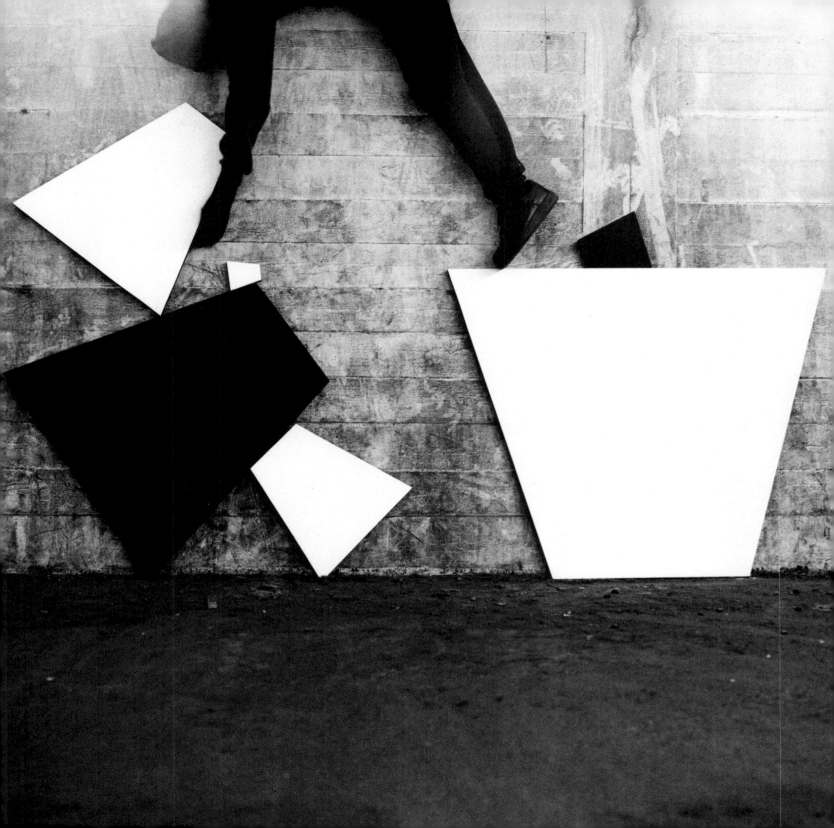

Robin Rhode in conversation with Stephanie Rosenthal

Stephanie Rosenthal **In 1997, you began performing with the objects you were drawing on walls and streets in Johannesburg. A year later, you started having your performances photographed, and in some cases you made animations from these pictures, which have been shown as video projections. For a time, galleries and public institutions invited you to put on seemingly spontaneous performances in their spaces but, in around 2004, you decided to concentrate mainly on spontaneous street works, which you perform to this day either by yourself or with your 'doppelganger'. How did this decision come about?**

Robin Rhode *I wanted to concentrate more on the aspect of drawing as a kind of cinematic apparatus. The extent of the drawing – or what I also refer to as the 'after-drawing' – was becoming more important. My timeframe for a work on the street was longer, unlike the duration of the live performances I was doing, which took a little less than five minutes. I had actually started working first on my own in a white cube, documenting on video my drawings and performances in the student ateliers. Back then, I did my work spontaneously and the drawing aspect was a lot more organic, sporadic, even crude in its rendering. But I decided that if I started working unannounced in the street, the process would be very similar to that of graffiti artists, to whom I had a strong territorial alliance. The streets were calling 'truth or dare'. And it's the notion of extended time, a result of not having a traditional audience, that has allowed me the space to develop narratives within the confines of the inner city. The audience has become the day-to-day city dwellers, commuters and tsotsis (hustlers) who bear witness to my fictional narratives, which alter the meaning of their city streets. Another reality, constructed by drawing and mark-making, can live within a marginally-existing world.*

SR **Who Saw Who is your first solo show in Great Britain. What does it mean to you to have an exhibition in London, the capital city, in view of the fact that the English language and the English system has played such a crucial role in South Africa?**

RR *The British system seems familiar but foreign to me, almost ancient. Even though I appreciate the eccentricity of British culture, I do not concern myself with its kind of Dickensian theories and Victorian idealism. Common sense is my order of the day – when I so decide. I grew up within a British system, a colonial system, starting with the language and sports – that was very important. I played cricket and football growing up; all I wanted was a pound but all I could get was a 50 cent piece (S.A. rand). South Africa has modelled itself on the British system in terms of education and Anglo-Saxon politeness. The first foreign destination of choice for South Africans is London, so the terrain seems quite familiar. There still seems to be a kind of nostalgic response to South Africa amongst South Africans living in London, almost as if local South African culture can be replicated and experienced first hand in Britain. I totally disagree with this practice, especially*

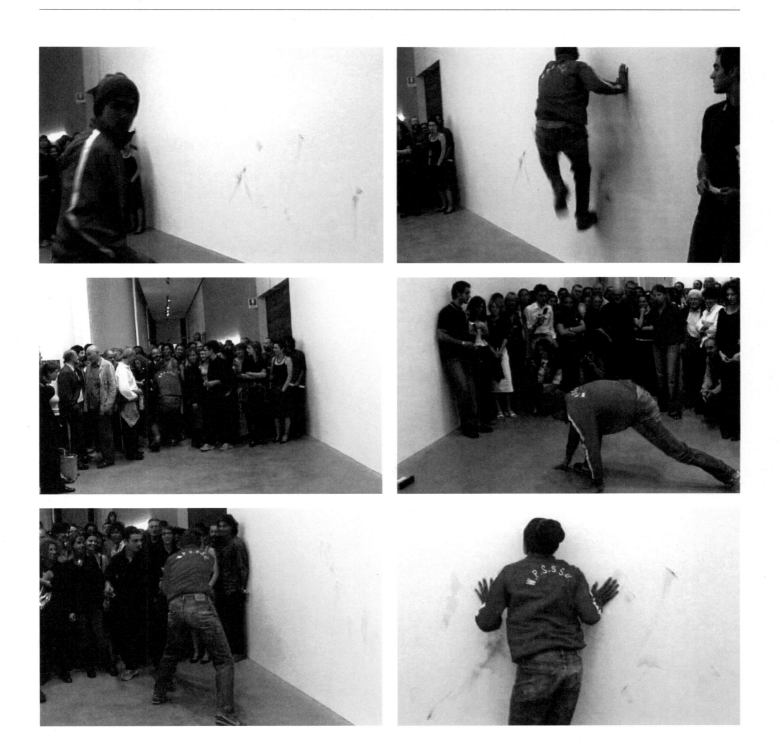

Untitled [2003]

amongst certain racial groups who still embody the narrow-mindedness associated with a pre-democratic South Africa. There are also a number of political exiles who reside within Great Britain's borders. South Africa had many exiles during the apartheid era – writers, artists, political activists – and the British system became a device with which to educate and empower those within the struggle.

SR Your views on South Africa are reflected in your work, but not always as openly as in the Gun Drawings.

RR The Gun Drawings are important in that they play off many subcultural gang codes in South Africa, but also because they relate to a broader spectrum. The drawing titled Desert Rabbits alludes to rabbits being hunted with a firearm. Junky Funky Kids refers to children playing with toy guns, but also significant is that the first three capital letters in this title are JFK – John F. Kennedy. There's an upside down drawing, The Hard Livings, where the gun is positioned dead on its back; The Livings are an extinct gang from Johannesburg that were hunted down like rabbits. Or the finger-smudged, finger-printed drawing F.B.I.'s, which is another Johannesburg-based gang with its name taken directly from the United States' enforcement agency. The drawing titled The Americans takes the name of the biggest gang in South Africa, which is based in Cape Town. This gang actually wears American scarves and bandanas as their colours, and we all know that America is home to the toughest gangsters in the world.

SR Another work with a direct reference to South Africa is Stone Flag.

RR The 'subject' of this piece is a typical South African landscape, beginning with the sun-baked concrete outdoor floor/ground that acts as the backdrop, which had been stained over the years by dog urine and washing powder (to remove the urine smell). The stacked bricks had degraded over time through summer thundershowers and electric storms. My intention was to allow the bricks to defy gravity, making the objects look lighter, softer, like a silk flag blowing in a gust of dust. Most of my work plays off a horizontal plane; with Stone Flag, the arc is the logical optical device to generate movement and velocity. That's where the 'matter' comes in, and how the content is composed, recreating an observable universe. The bricks become a metaphor for construction and building, while touching on ideas of violence and vandalism.

SR **The fact that you have been living in Berlin since 2002 seems to be reflected in your recent artistic practice. In the last couple of years, the studio has sometimes replaced the street as the place where you realise your sculptures, drawings and paintings. Is this an effect of the city of Berlin itself and finding yourself directly engaging with European art?**

RR *Berlin has offered me a different viewpoint, both on life and my artistic practice. In distancing myself from the familiar context of South Africa, I have had to dig deep to find new forms of inspiration and to investigate new methodologies of creating works of art. There is no denying the strong relation Berlin has to art history, dating back to Dada as well as the Bauhaus. This I do find inspiring. The city's political history raises complex questions about space, unity and division – certain topics that are quite related to my interests. Even though Berlin does not attract me in the same way that Johannesburg does – where I have the need to work in public or to work on walls – I have begun instead to adhere to a more analytical approach to the processes of art, which is a typical German trait I have come to appreciate.*

SR **The new strand in your work involves larger, much more staged performances. You are currently working on the set design for Modest Mussorgsky's <u>Pictures at an Exhibition</u> (1874) at the Lincoln Center in New York, by invitation of the virtuoso pianist Leif Ove Andsnes. Would you say that your work on this new commission has influenced your artistic practice in general?**

RR *Yes, it has had a ripple effect on my practice, which is healthy indeed. We sometimes need to function outside of ourselves to engage with discourses of which we have little or no knowledge or understanding in order to bring new thoughts and ideas to the table. I have no musical or dance training but this has led to a desire to understand more and to trust intuition, feeling. For example, with dance I have discovered a new definition of time, or performance time – that a dancer understands time not through duration but through the intensity of the body.*

SR **You have said that your engagement with Mussorgsky's suite led you to Constructivism, but looking back at your work from 2006 it already seems to be there.**

RR *Constructivist ideas may have existed in my earlier work but I was not too conscious of them. All the better – I don't want to control everything that I know or do.*

SR **It seems to me that you are able to create an alternate reality, which the viewer can almost believe in. The idea of freedom and anti-gravity in your works liberates the minds of those who come face-to-face with them. Utopia is visible in your work. Some of your new drawings and paintings reflect the work of Russian avant-garde artists like Alexander Rodchenko or El Lissitzky. For more than a year now, you have been experimenting with abstract forms. Is this also a way of creating another reality, like the Constructivists did – producing a space where gravity is irrelevant?**

RR *During this fraught period in our world it is important for a space of resistance still to exist. This space or dimension is only accessible through the imagination, unlike our reality that includes certain things while excluding certain others. This imaginative space harbours a desire to look at the world anew using humour and play to destabilise the unseemly. Humour and gesture become important catalysts in connecting directly with the unconscious. It's not so much about loss of gravity but more about disrupting our experience of the real.*

SR *Your work has its roots in your ideas of human existence, of essentialism, so is there a spiritual side to your work too? By spiritual I am referring to artist Kazimir Malevich's notion that it is only by abandoning objecthood, by breaking down barriers, that the artist can enter an abstract world, which Malevich did with his motif of the black square.*

RR Human essentialism has always been fundamental to my practice while adhering fleetingly to both Suprematist and Constructivist ideals. My focus has always been in favour of art directed towards social concerns, while relying on reductivist principles in order to highlight political thought. The question of existence allows us to address the necessity and meaning of art today, which rather seems more to do with itself than the human condition. This is very much understood in Malevich's black square.

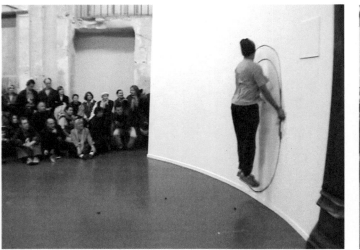
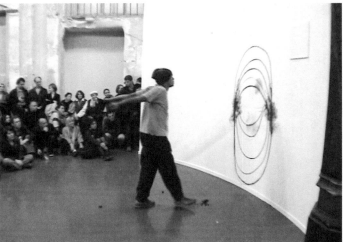
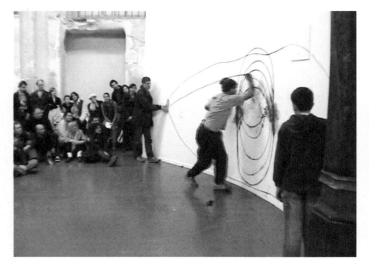
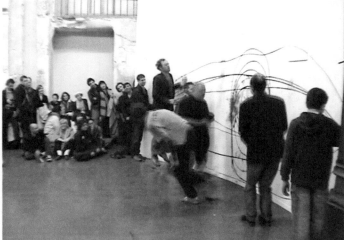

Untitled (Skipping Rope) [2005]

SR **Another link I see between your work and the Russian avant-garde is the fact that a central part of their artistic approach was collaboration. You have worked with the dancer Jean Baptiste André, and for several years, you have been collaborating in some way with your doppelganger. What does collaboration mean for your practice?**

RR *Collaborative projects allow for the decentring of the self; it was my intention to shift further away or out of the pictorial frame altogether, while still maintaining a level of control, however slight. My position during the realisation of the idea has become more distant. From afar, one is able to gauge more re-evaluations on a given form. Distance becomes freedom. The idea of the doppelganger or alter-ego, a ploy used extensively by Marcel Duchamp in his female character Rrose Sélavy, confronts the artist with his shadow self. This shadow self becomes a model for the unconscious. My doppelganger usually finds himself existing inside visual narratives that are rendered in drawings wherein he needs to find an escape route, a very basic narrative device of the equation 'problem/solution', which reflects the tension between the rational mind and unconscious desire. The performance then begins to embody a kind of cinematic apparatus in rendering the meaning of the work itself.*

SR **Your recent abstract works seem to have grown out of your performative, photographic works. For The Hayward exhibition, your photographs, drawings and projections will be shown together on one wall. Your paintings seem to connect strongly with your interactive drawings on the street. How do you see them?**

RR *I see the paintings as a kind of industrial production of the mind from which new images can resonate. The painting process is very much linked to photography, similar to Man Ray's Rayograms, where objects were placed on paper and covered with emulsion before being exposed to light, thus leading to a negative/positive or shadow image. In my case, I construct a cardboard cut-out similar to graffiti stencils, and apply spray-paint through the stencil. The paint becomes the photo-emulsion with the end result creating an optic effect that begins to animate itself on the retina of the eye through the repetition of forms. This allows for a time and space articulation on a three dimensional plane. The paintings reject the human form and embrace a non-Euclidian geometry that can extend into any infinite number of dimensions. The scale of the paintings is very human in terms of reach and gain. Scale reflects the human form while still embodying the implication of distance. Painting as doppelganger, no?*

SR **Is Kite a crucial work in this context, since it brings together so many different aspects of your practice?**

RR *Yes, Kite is an amalgamation of familiar forms and mediums that I've been engaging with over the last few years. But it could be viewed as acting as a departure towards something else rather than harping on the familiar. Therefore, it hints at an evolution in my artistic practice, which has occurred rather organically.*

SR **The Hayward was built in 1968 and is part of Southbank Centre. In connection with your Hayward exhibition you have decided to intervene in the whole Southbank site by realising drawings <u>in situ</u> – your main point being that this show is not about spectacle, but about ephemeral appearances, apparitions. These works will exist in parallel to the show and will have a major impact on the way that your work is seen and thought about. For these drawings, will you be working with a figurative object, or have you decided to go for abstraction and abandon narrative?**

RR *I have decided to move away from a specific narrative, to use abstract forms as a device to reframe the body within the given architecture. I'm interested in the body mimicking clear geometric forms with architecture as surface, sometimes as medium.*

SR **How do you try to build up a relationship with the architecture?**

RR *Once you start working and conceptualising ideas within the given architecture the relationship has already begun. I try not to think too much about the architecture as I always believe that it's a far easier route to bring one's own history or ideas into the relationship rather than relying on the inherent history of the architecture. Architecture becomes a muse.*

SR **Are you taking more risks now by not using figurative objects and breathing life into abstract forms? You seem to be going a step further towards an alternate reality by asking people to believe in the importance and the presence of an abstract form. Yet you underline their impact by always linking these forms to a real person. It seems there is no end to your interactive narrative.**

RR *Yes. There is no curtain call to that narrative.*

SR **In your recent discussion with William Kentridge in <u>Modern Painters</u>, you mention that form always comes first in your work. But I would like to suggest that content <u>follows</u> form, especially in your earlier work. The starting point of your work seems to be a trust in the capacity of the human imagination to create valid realities. This manifests itself very often in a narrative, which is triggered by a drawing of a real object or the use of a real object in your performances.**

RR *The question regarding 'form over content' or 'form before content' is an interesting one. I firmly believe that content already exists or is inherent before a work is realised, or before a mark is made, or a line is drawn. The artist himself embodies content, whether it manifests itself through a politicised self or Other, this level of content balances itself against form. I try not to be too conscious of content, even taking it for granted so that I can have a free understanding in trying to emancipate form.*

SR **Talking of forms – for over a year, the diamond shape has recurred in your work. The diamond is one of the world's most precious raw materials; it is certainly the strongest, and almost indestructible. I've read that roughly 49 per cent of the stones originate from central and southern Africa. So, form or content?**

RR *The diamond influence has been more formal than anything political. Beyond the issue of 'conflict diamonds' or the religious and ancient iconography of the diamond, I've been fascinated by the dynamism of the diamond form – the sharp points and angles, the cutting, the implication of the infinitive,*

and that the shape can rotate or be placed in any direction – and also, more importantly, that the form disperses light, therefore affecting optics, distance, perspective and so on.

SR **What about the sculptures that you have realised for The Hayward's sculpture courts? When you started making sculptures in about 2007, you talked about the fine line between the ephemeral and the enduring. Is this still what drives your thinking about sculpture?**

RR *I maintain the interest in my sculpture functioning the same way as my drawings – that sculpture harbours questions around time, the ephemeral, but more as extensions of the unconscious. I continuously ask whether it endures in the same way, questioning the need for sculptures and forms to exist. If they did not, then how could I know and how could I possibly ask the question? Art has always been more about questions than answers and never more so than in my realisation of three-dimensional forms.*

SR **The other work that you have conceived especially for our exhibition is a large wall drawing for the undercroft of the Queen Elizabeth Hall at Southbank Centre – an internationally-known site for skateboarders and graffiti artists since the mid-1970s. This wall painting is crucial as it recalls your much earlier work as a sporty urban artist. It seems to have taken you back to your roots, but clearly you have moved on visually, you are really somewhere else now. What are the main issues that concern you these days?**

RR *The main issues have a lot to do with reclaiming space and its meaning, the function of the realised wall drawing and the politics within the various subcultures that exist within the given space – skateboarders and graffiti artists, mostly youth related. The process of the wall drawing becomes just as important as the end result since a relationship has to exist between myself and the subculture. My project is one of impermanence, which exists one day and then disappears another, as it is quite obvious that graffiti artists will 'bomb' my wall drawing. The project aims to highlight a particular space rather than own it in any conceptual way. My idea for the project is to create an optic environment using layered geometric forms that are sprayed directly onto the wall through a stencil. These forms could animate the environment, or fourth dimension, with the skateboarders moving through the space.*

SR **Thinking of that drawing, it almost seems as though Southbank Centre is standing on the pillars of the undercroft, which connects with the pillars in <u>Empty Pockets</u> and <u>St. Bernard's Parish</u>. You have mentioned Babylon in relation to these two works. Can you explain that?**

RR *Regarding <u>Empty Pockets</u> and <u>St. Bernard's Parish</u>, it is more the Babylonian worldview of a flat earth standing on pillars. The idea of a flat Earth is found in mankind's oldest writings. The introduction of a spherical object (the pool balls) interrupts the firmament or horizon. The upside-down theme in both works becomes a point of direction that is almost arbitrary – north and south, or high class, low-class.*

SR *Yes, it seems that you're almost walking a tight rope between these huge issues of dimensions, with ancient mankind on one hand and real South African history on the other. In Juggla, one can see a direct reference to the history of the Coon Carnival in Cape Town. How did you come to this figure?*

RR *My character in Juggla is based on both the personal experience of seeing minstrels or 'coons' perform in Cape Town and a character called the 'The Turk' from Oskar Schlemmer's 1922 ballet titled Triadic Ballet. The influence of Schlemmer's Triadic Ballet allows me to counter an emotional or personal position within the work, since as a child I followed and supported coon or minstrel carnivals. The minstrels became a ubiquitous form, rows-upon-rows of people, characters, the painted face as mask, a moment where the minstrel owns the street. The performer in Juggla is a man with painted hands, while in Schlemmer's ballet, The Turk wears cymbals around his wrists and hands, which I interpret as percussion hands.*

SR *In a text I wrote recently, I described you as a clown in the sense that you are so often playing with reality.*

RR *I fail to see your point regarding clowning. I prefer jester over clown. As the jester says in Twelfth Night, is it not better to be a witty fool than a foolish wit?*

SR *What about figures like Buster Keaton or Charlie Chaplin? The way your doppelganger is dressed and acts has some similarities to these silent film stars.*

RR *The only relation is the silence of early cinema, from the moving image towards a single frame. I never looked at Buster or Charlie.*

SR *And, finally, can you explain your title for The Hayward show, Who Saw Who?*

RR *There is always a relationship between the past and present when we decipher forms and ideas that impact our lives. The past has always affected our interpretation of the now in terms of appropriated imagery, of who looked at who, and why. My title, therefore, reflects a duality between real time and time elapsed. In terms of my own practice, the idea of 'Who Saw Who' touches on a relationship that exists outside of the frame, more within the realms of ideas, the character or alter ego, which is my doppelganger. My question 'Who Saw Who' relates to the co-existence between me and this shadow self, about who I am and what I can become.*

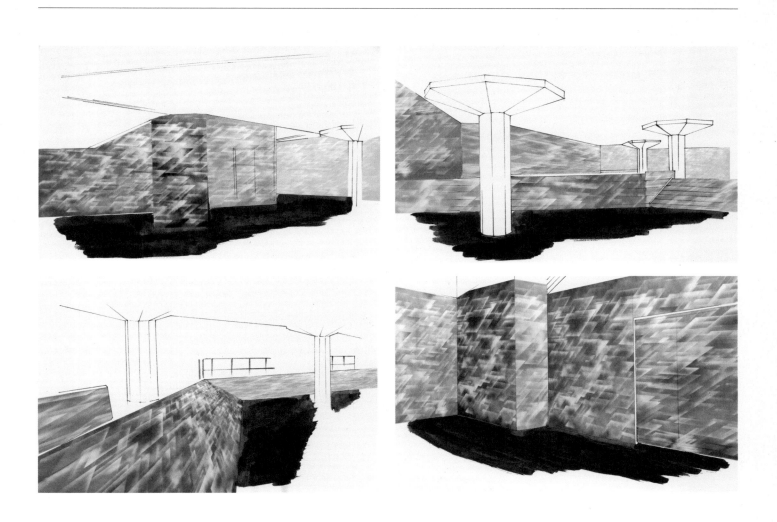

Artist's Impression (Queen Elizabeth Hall undercroft) [2008]

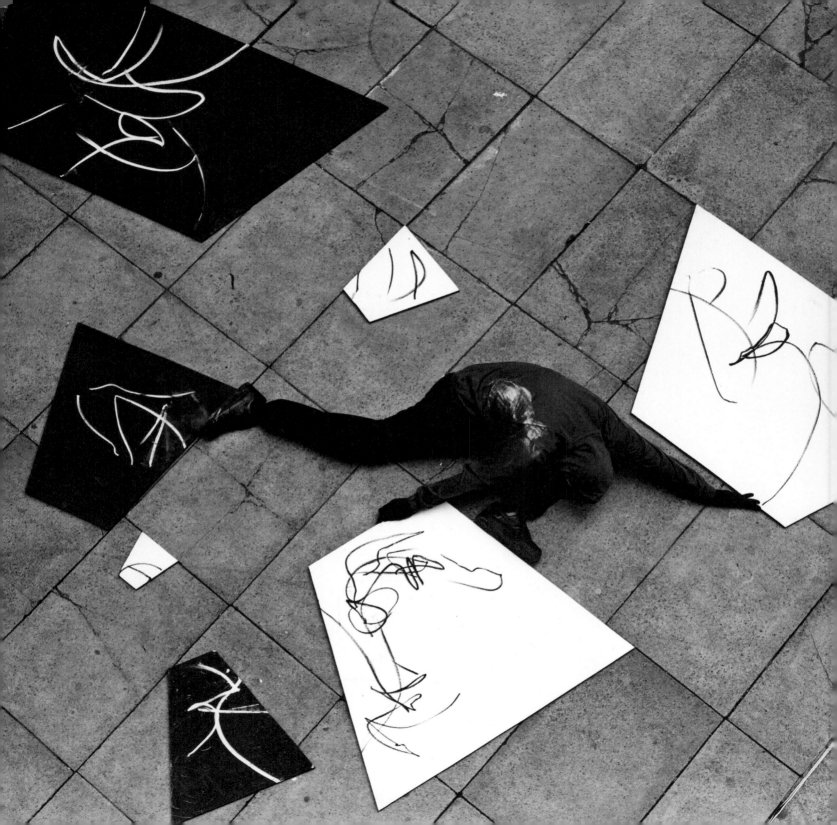

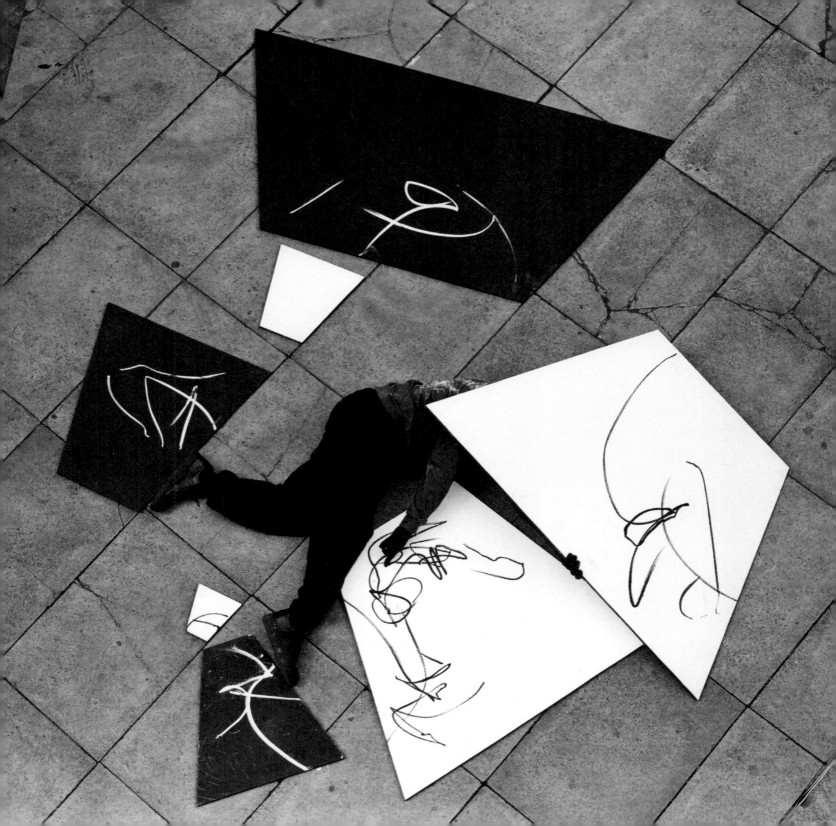

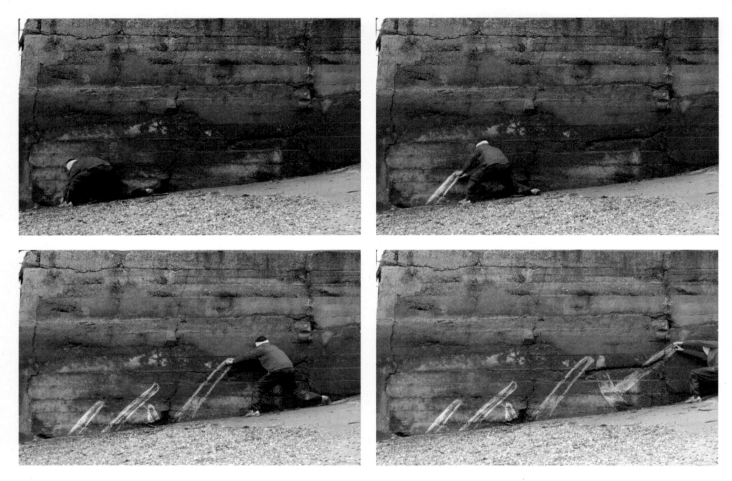

Untitled (Anchor) [2005]

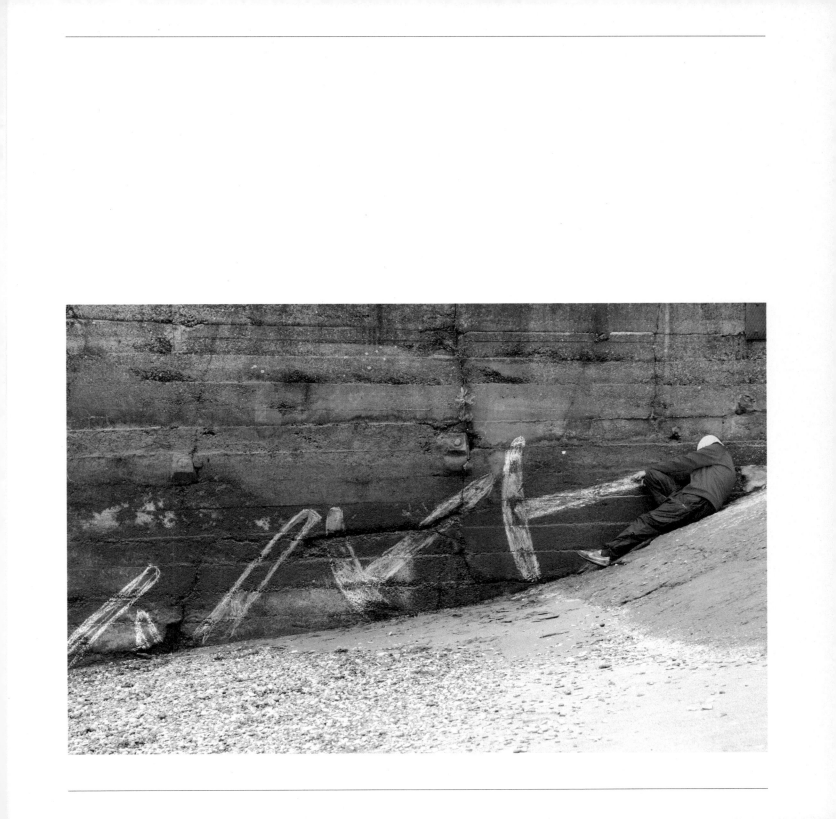

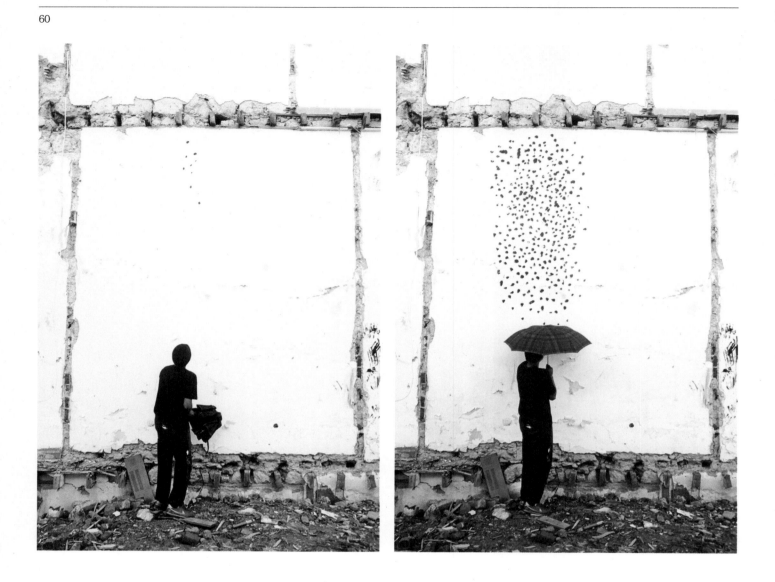

Untitled (Hard Rain) [2005]

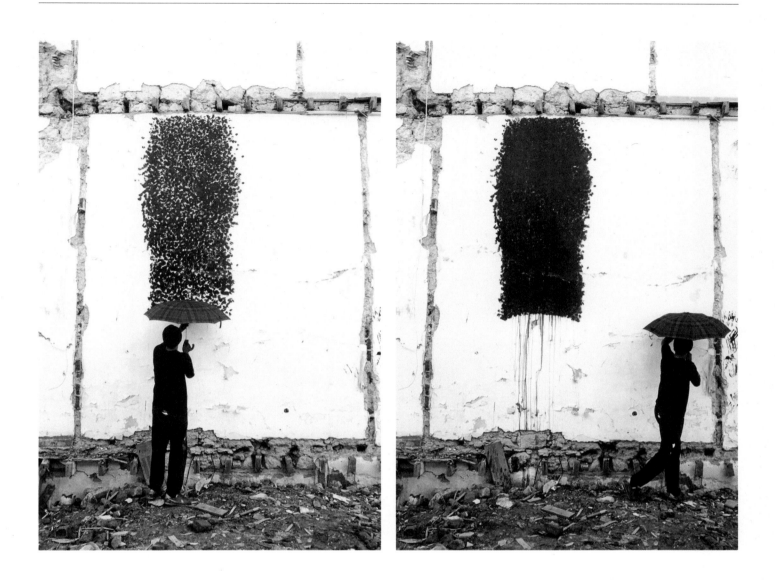

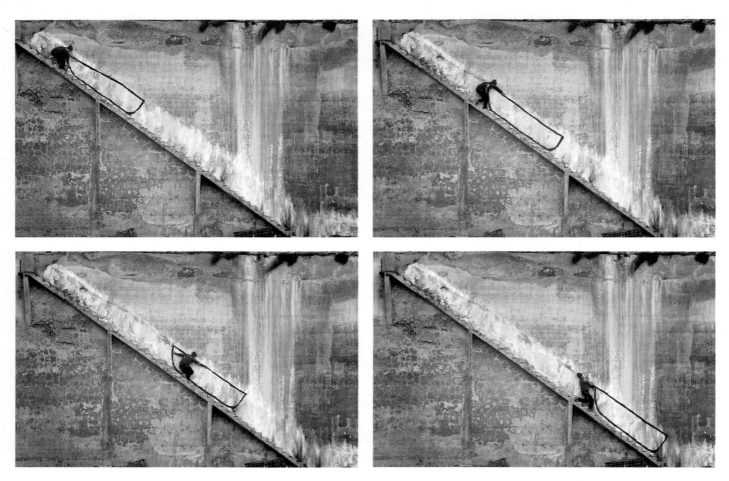

Untitled (Landing) [2005]

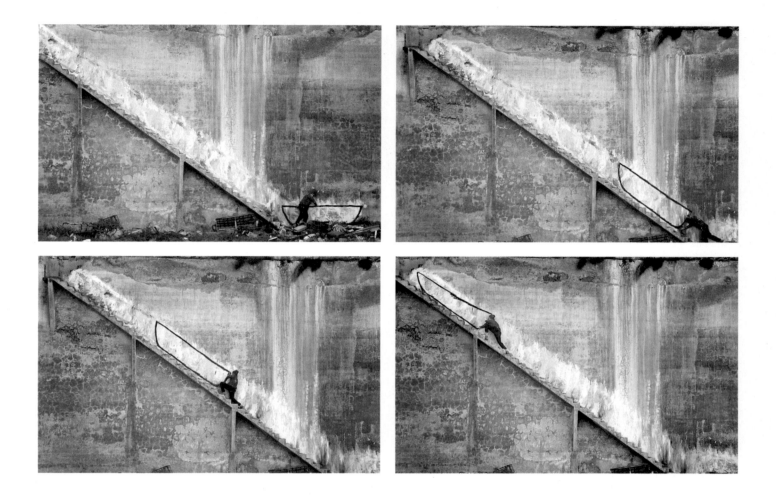

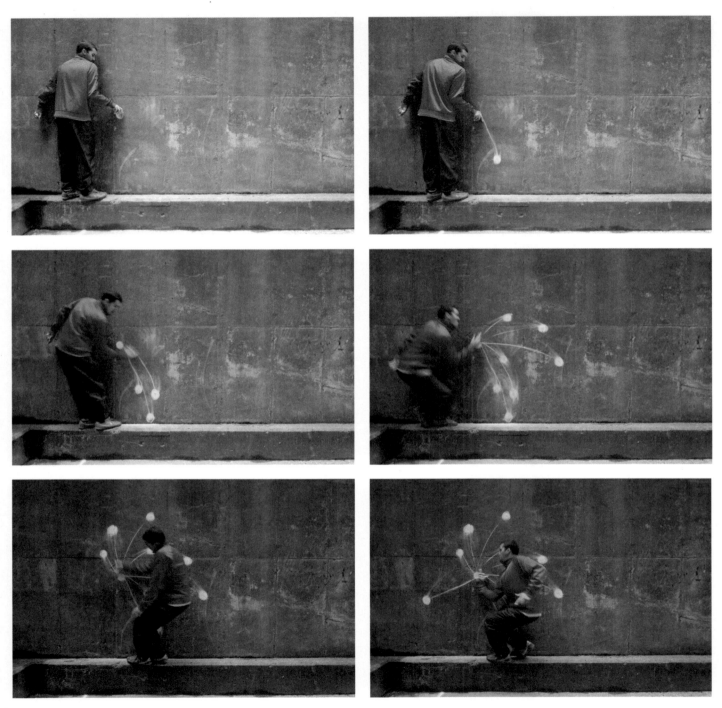

Untitled (Yo Yo) [2005]

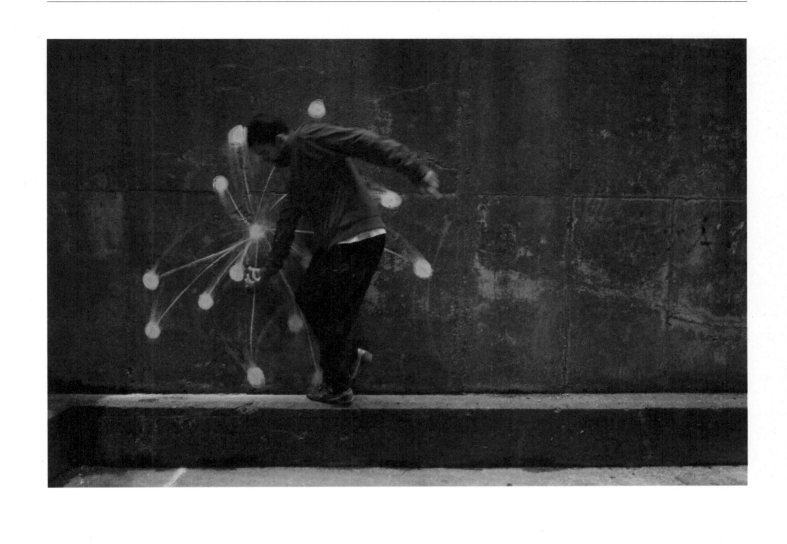

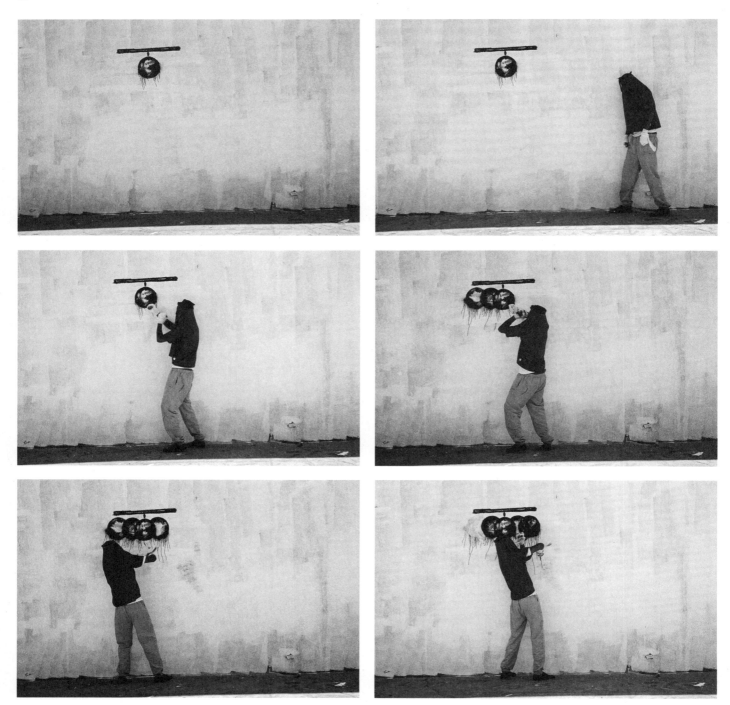

Blackhead [2006]

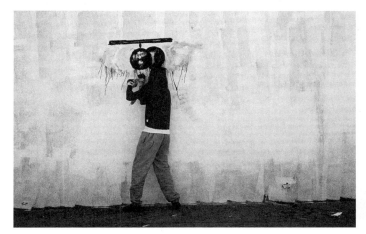
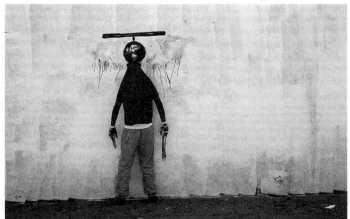
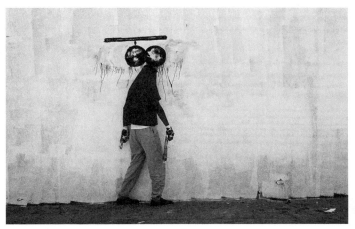
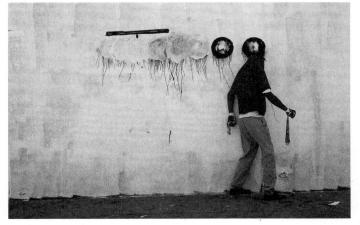
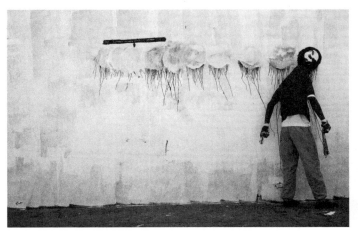
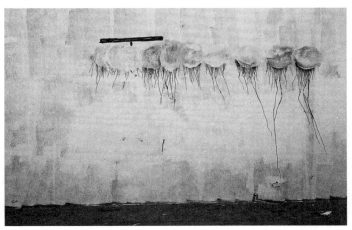

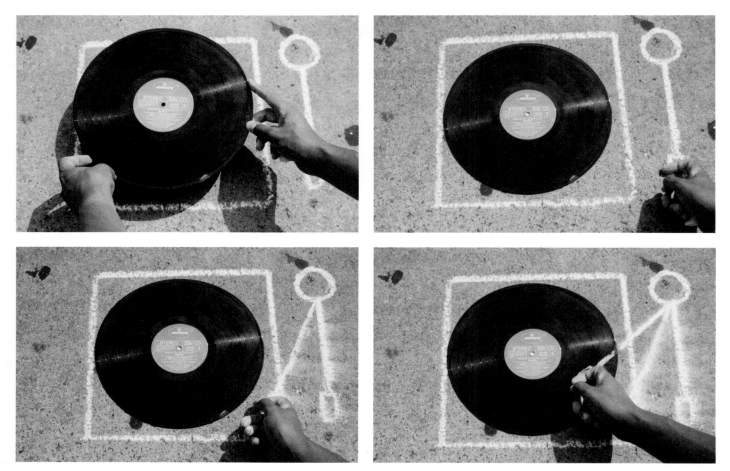

Wheel of Steel [2006]

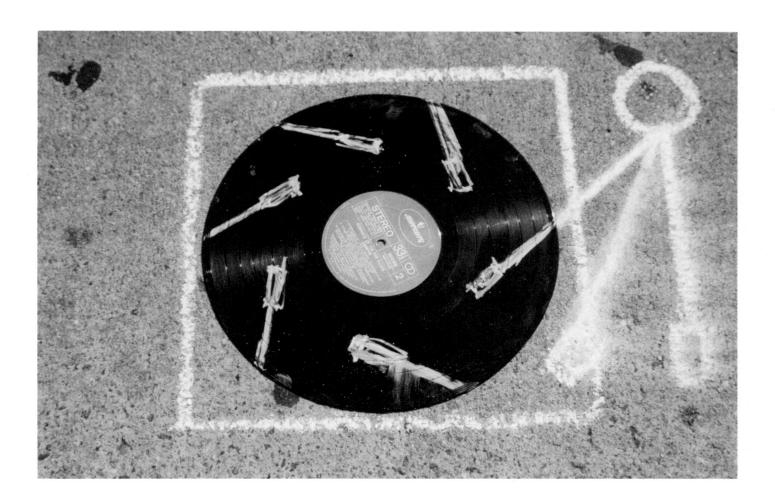

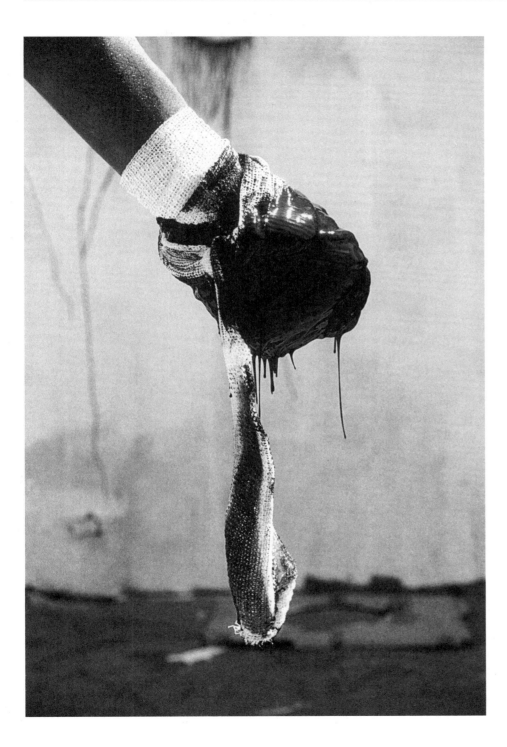

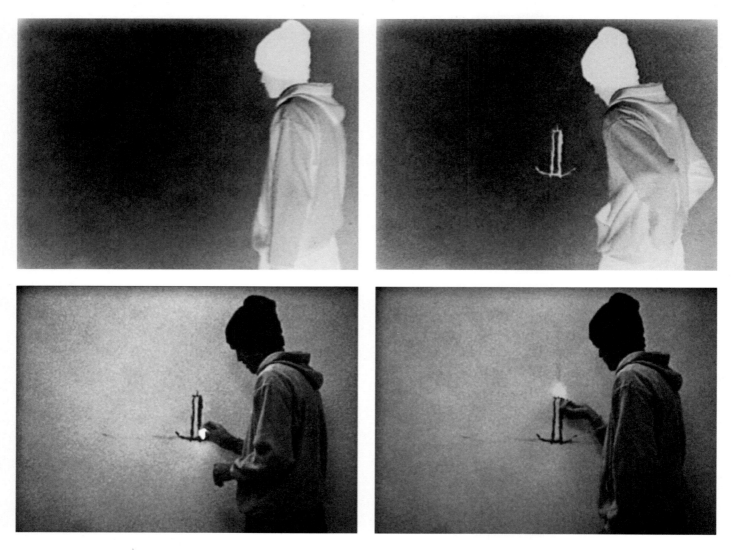

Candle [2007]

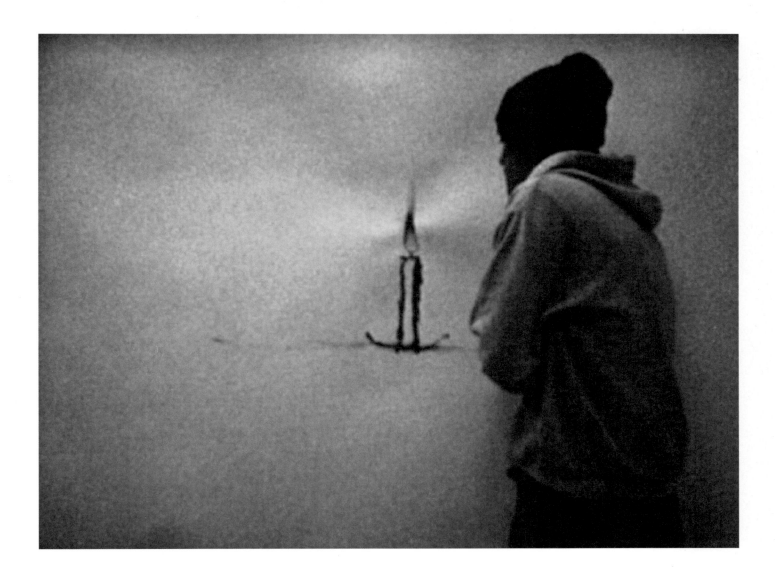

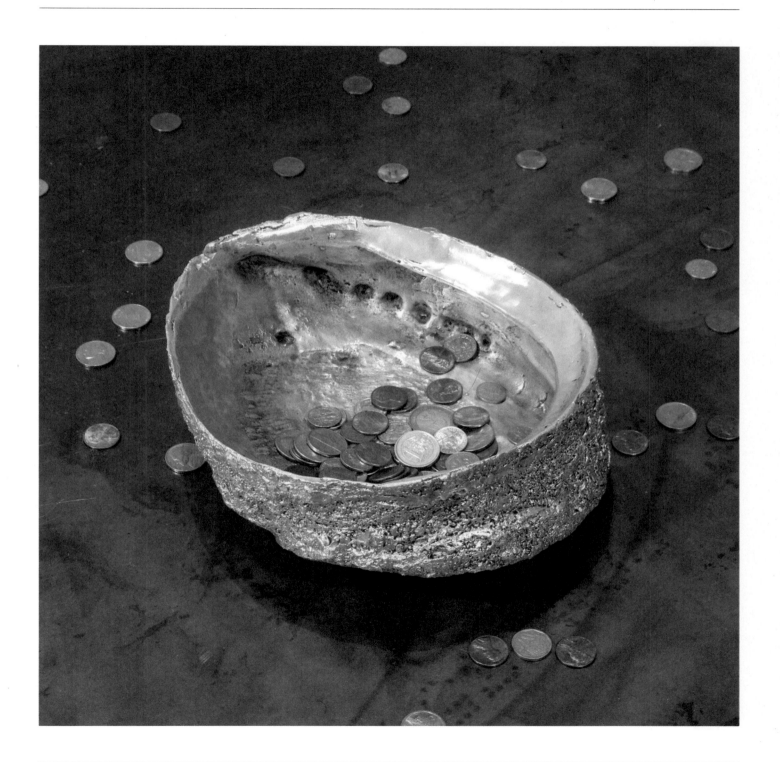

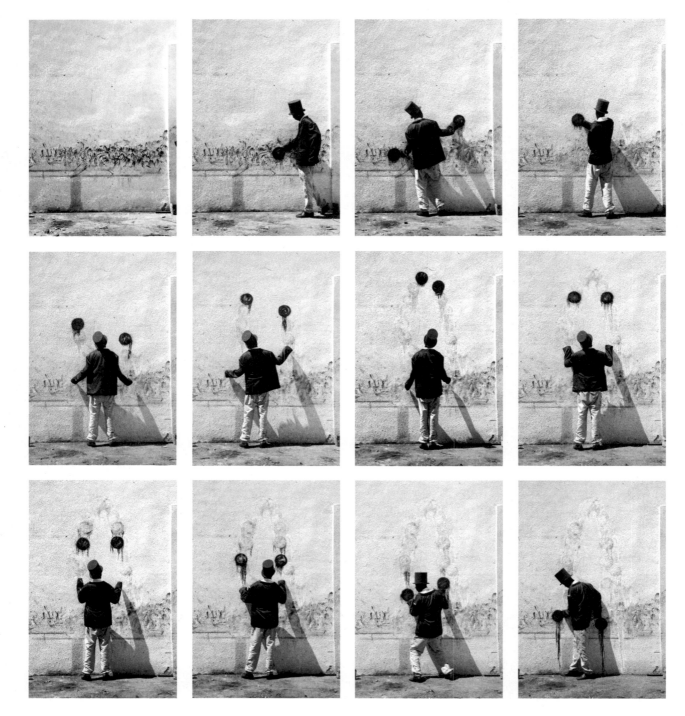

Juggla [2007]

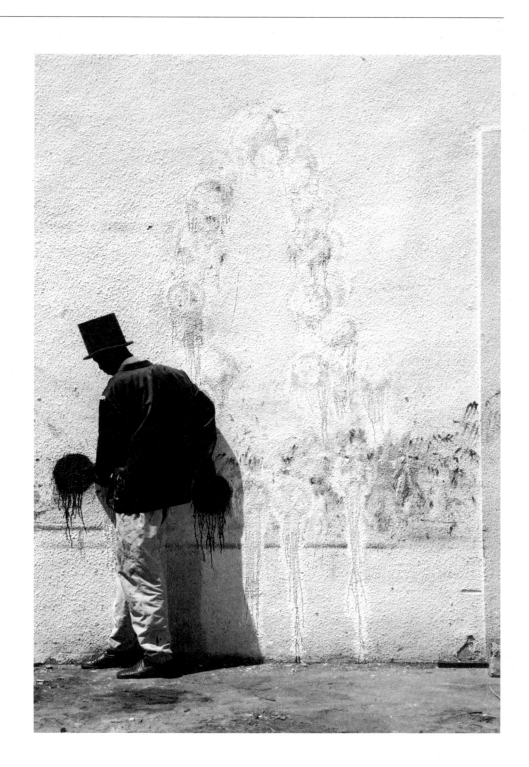

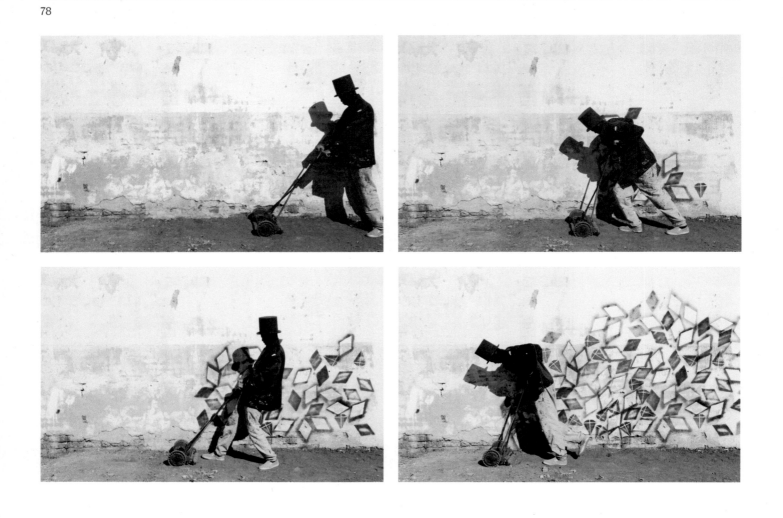

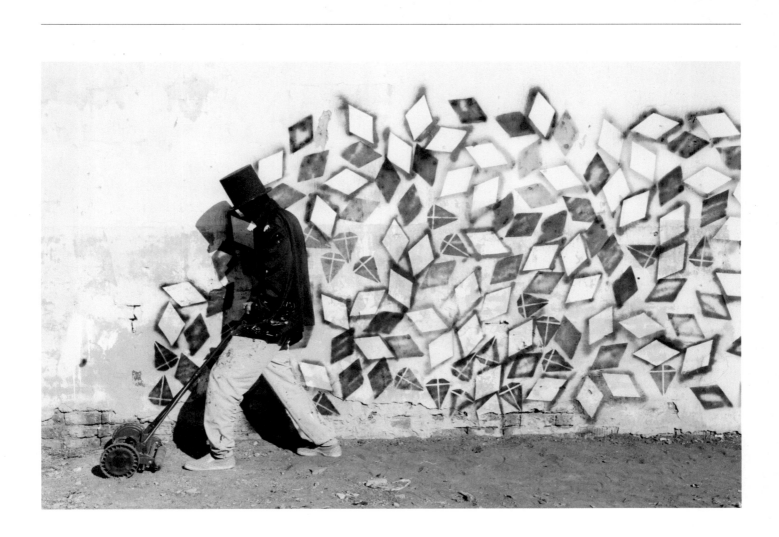

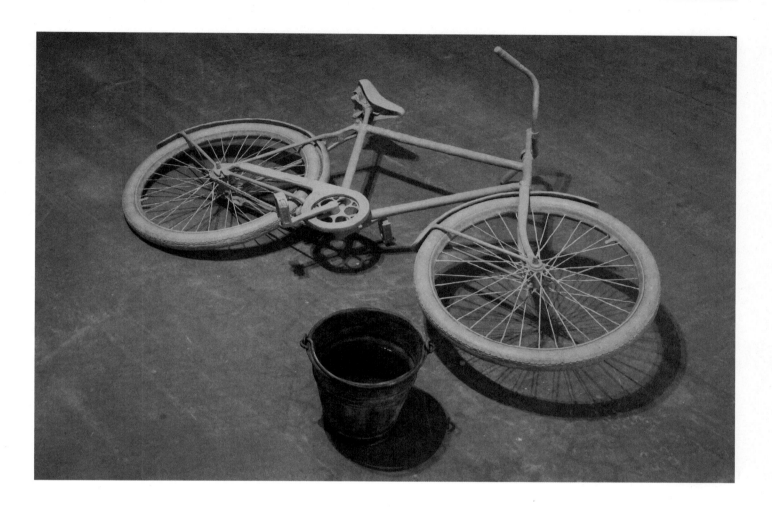

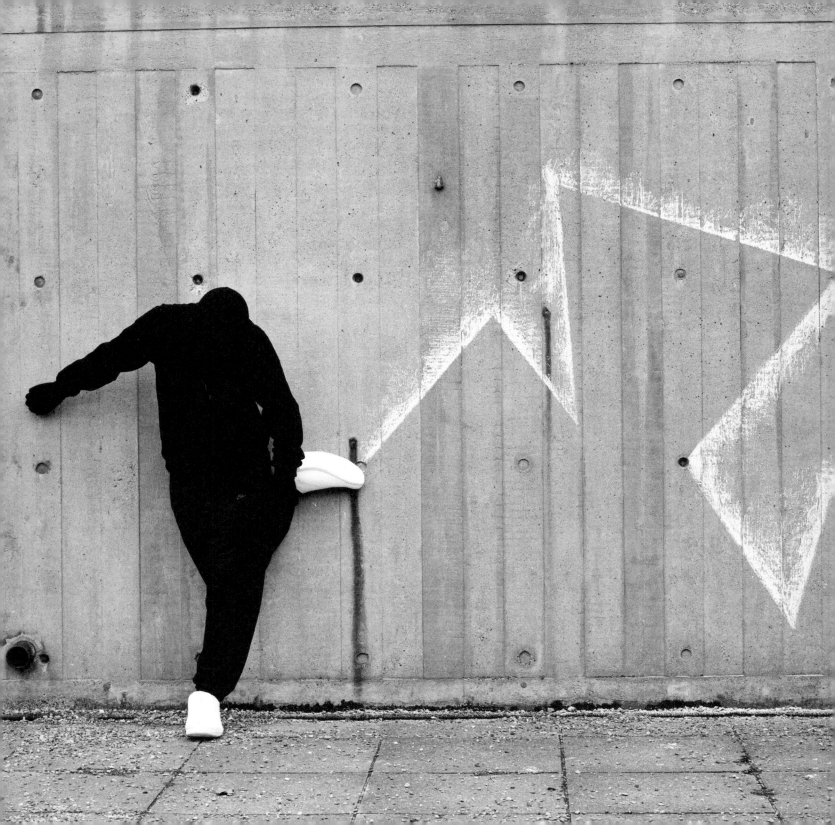

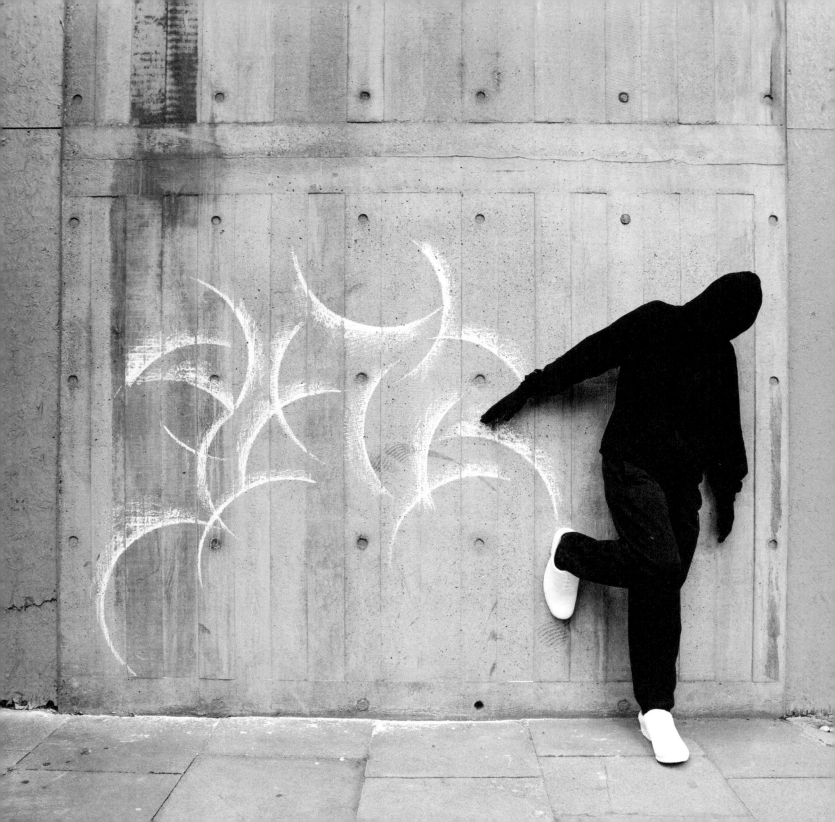

Handwriting on the Wall
Michele Robecchi

The first-ever film with a synchronised soundtrack, *The Jazz Singer*, premiered in New York on 6 October 1927, and marked the beginning of a revolution in film, theatre and visual art. The age of talking pictures was officially born, and over the years it would change the face of slapstick comedy forever, elevating the Marx Brothers, destroying Buster Keaton, and granting survival to a few versatile figures from the silent movie age such as Charlie Chaplin. During this period, a little-known art form called 'Vaudefilm' occurred, in which Vaudeville artists, eager to adapt their theatre to the new cinematic world, introduced film to their performances by providing a live musical soundtrack to the fascinating but silent moving images up on the screen. A dramatic inversion had taken place, with vaudevillians' physical performances now relegated to extra acts. But as soon as theatre owners realised that the rental costs of films were significantly less than real actors' booking fees, the age of 'Vaudefilm' was over, and theatre and film went back their separate ways. Robin Rhode's practice also incorporates elements of film, theatre, culture and music. His background, which includes growing up at close range to the street culture of

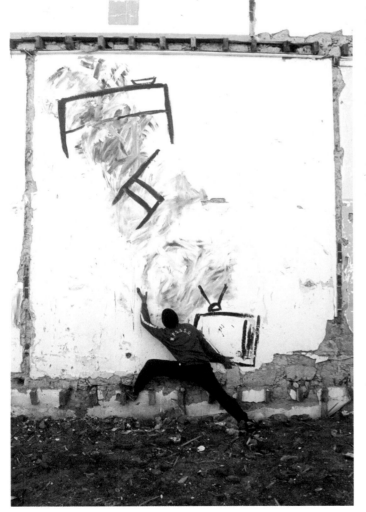

Johannesburg and attending the South African School of Film, Television and Dramatic Arts in the city, pictures a construct not dissimilar to 'Vaudefilm', and partially explains why his work touches on so many different aspects of visual culture.

In Rhode's work, human presence and movement play an essential role, with the wall or the street representing what playwright Samuel Beckett used to call the 'empty room' – a space where entire universes can be made and animated just by the placement of a single object or person. In conventional theatre, set design plays a complementary role in defining the space where the action takes place. Essentially, it gives visual support and credibility to the actors moving within its domain. In opposition to film, where there are no prescribed limits, the theatrical set is framed and reliant on the spectator's predisposition to forgetting the surrounding environment and accepting the tacit rule that the action happening in that rectangular space is actually true. Rhode's work moves along these lines. Despite its clear cinematic characteristics (his photo sequences resembling a series of film stills), his work asks the spectator to acknowledge the active status of

Untitled (Dream Houses) [2005]

Snake Eyes [2004]

the background, an entity that responds accordingly to his characters' movements by assuming different forms as the artist creates objects on its surfaces, deletes them or makes them float as if they are unbound by the rules of gravity.

Rhode's backgrounds of choice are mainly the streets and walls of Johannesburg, where the artist has illustrated episodes from his daily life – his aspirations and frustrations – in processes that range from fabricating bicycles to representing spectacular and implausible somersaults, slam dunks on a basketball court, dice shootings, and over-the-top New Year's Eve celebrations. At the same time, his work surreptitiously conveys more about the current state of the city and much of its population than it appears to let on.

The street and its casual public provide the ideal platform for Rhode. Just as Rhode projects into his work his own personal history, the walls and sidewalks of Johannesburg tell a contemporary story that updates itself with the same rhythm by which inner city people live their lives. As if to confirm this, on many occasions bystanders have voluntarily helped the artist as he attempts to interact with the two-dimensional objects that he has drawn on the walls and streets. Unlike in an art gallery, where visitors are traditionally obliged to keep their reactions in check, viewers in the street can properly appreciate and share in the artist's struggles.

The driving force that pushed Rhode to stage his art in the streets, as opposed to the secure environment of the studio, has a historical precedent in the sixteenth-century Italian travelling theatre group *Commedia dell'Arte*, where actors with very few props presented semi-improvised performances in the street. Links can also be traced to Medicine shows, puppet theatre, the *Royal de Luxe* theatre company, as well as the street performance work of Surrealist and Fluxus artists. The strategy of bypassing the more trained theatre audience to indiscriminately reach a wider public allowed these comedians the freedom to address and satirise current events. In Rhode's case, creating art on the streets provides an opportunity to import the city of Johannesburg into his pictures and free his work from the burden of art history. Instead of building on art history, Rhode takes a different slant. His strategy is not to try to vouchsafe a hypothetical future by a complete disregard of the past, but to capture the present tense by making art that 'reinvents an existing

history based on sub-cultural codes, whether that be violence, graffiti, hip hop, or anything related to a marginal thought, experience, etc.'[1]

But, of course, the urban environment is not a totally virginal territory in terms of the visual arts. In the 1980s, graffiti artists were invited off the streets to sully the white walls of New York art galleries, a process that arguably resulted in a loss of energy and credibility. But Rhode has done the opposite, and has employed contemporary art codes in the context of the street – an area that has been up to this point relatively unexplored.

Graffiti art has a parallel history of decontextualisation, desire and liberty, and has contributed to Rhode's discourse by giving it more definition. As the artist himself recalls, his exposure to the graffiti community has been significant in giving him a better understanding of his position as an artist. Recently, when working on a wall in Johannesburg, he encountered a couple of graffiti artists who made him reflect on his practice. They could see the spirit behind his work but could not approve the style. As one of the graffiti artists said to Rhode, 'What you're doing is so abstract, there's nothing that you communicate, your works exist on the roll of film, this is not graffiti, you should be doing that in the studio, dude.'[2] It is a relevant comment that helps to explain why Rhode's work, despite its 'street art' credentials, does not actually present any connection to that world. Rhode's early pieces undoubtedly borrowed a lot from street culture, but weren't designed to be permanent and, unlike graffiti, they stopped communicating the minute the artist walked away.

Graffiti is only one side of the multifaceted medal of hip hop culture, and hip hop music is indeed the soundtrack that comes to mind when looking at Rhode's early work. The links with this movement are quite evident, and have been highlighted by the artist himself – marginality, subculture, street life and, above all, the timescale of the music. Hip hop's power is predicated on its immediacy. Rhode's moving images similarly work on the moment, and what is left after the artist is finished his work is little more than marks on a wall. Their life ceases to exist once the human presence is gone.

It would be wrong though to see hip hop as the ultimate form of spontaneous music. Other types of music such as jazz and blues have been through a similar mutation following

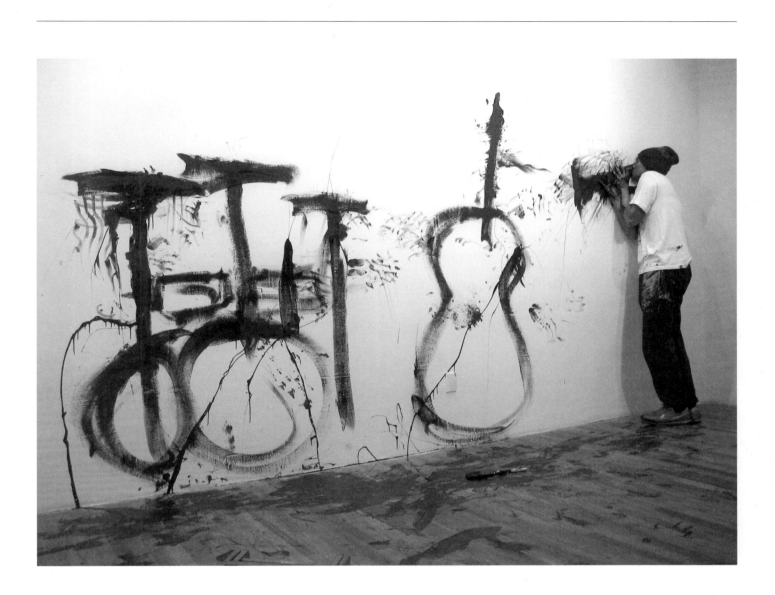

The Score [2004]

their urbanisation. In the 1930s, blues musicians moving up north from Mississippi found themselves having to quickly adapt to the slicker and more sophisticated audiences of Chicago and Detroit, which demanded electric sounds, smart suits and urbane manners. When the first generation of city-born musicians felt the urge to rediscover the true spirit of the blues and took a trip back to the country some years later, it found a world where people had developed a stunning creativity to make the impossible possible. New England-born musicologist and musician Taj Mahal observed after a visit to his relatives in Gulfort, Mississippi, that, 'these cats were serious. They were like Original Joe – the mystical character who, because he ain't got nothing, he always figures out how to do something. These guys would take radios and turn them into amplifiers. They'd get up there and play their one or two or three tunes, and that stuff would be just cooking.'[3]

The spirit of Original Joe seems to revive itself in Rhode's work *The Score* (2004), a performance that took place at the Artist's Space in New York and is one of Rhode's most overtly music-oriented works. The artist air-played one-by-one a set of instruments painted on the wall, composed of a bass,

drums, keyboards and a trumpet. The soundtrack, provided by Rhode himself, was created by miming their sound with his voice – an exercise that laid a bridge between scat and the vocal acrobatics of generations of jazz singers and the beat-boxing effect utilised by hip hoppers.

Another influence in Rhode's work can be tracked down to improvisation – a creative *modus operandi* often associated with jazz and blues, with the construction of well-defined structures that leave room for improvising only on repetition. In a similar fashion, Rhode's work mirrors that sense of freedom and immediacy, but it is not about the artist standing in front of a wall and painting until something appears. His street interventions take place on the spot, are open to variations and contaminations, and have drawing as their starting point:

'My work essentially exists as drawing. The drawing gives rise to the performance because in most cases the drawing is in a storyboard format. It made sense to recreate the storyboard photographically. From the photograph it made sense to extend the narrative into a series of moving images. The moving images extended into a more filmic

narrative, which filters through into a theatrical or operatic sense, and then this theatrical dimension feeds back into the performance. Ultimately, the performance exists as a kind of drawing study, and it is these drawing studies that are the starting point for the works. The idea stems from my reactions to where I am and how I feel at a given time.'[4] Another work from Rhode's 'music' oeuvre, the black-and-white photographic series *Wheel of Steel* (2006, pp. 68–69), touches on these same issues although in a hefty romantic way. A vinyl record on the street looks like the quintessential hip hop image, but there is a vintage flavour to it that resembles great music from the past, possibly the consequence of the choice of the record in question – Romanian flutist Zamfir's *Romance of the Pan Flute* (1990). In *Wheel of Steel*, the white chalk lines framing the record and creating a basic turntable highlight the formal qualities of the vinyl. Not interested in perfect deletion, Rhode left the marks of the moving coil on the vinyl as the record spins so that, multiplied, they give the round black object a new form.

Rhode's close relationship with the walls of Johannesburg give his work a site-specificity that is not immediately perceptible but is ultimately central to his practice. This aspect had to be reconsidered when he moved to Berlin in 2002. The historical atmosphere of Berlin and the typical European tendency of thinking of the artwork in an analytical way clashed with an artistic discourse that until then had revolved around instinct and freedom. After a period of adjustment for Rhode, the first consequence of this European move has been the inclusion of more formal tones in his work, although these could also be seen as the result of a process of artistic maturation. A slick black and white has replaced the chromatic enthusiasm of his earlier compositions, and the introduction of more abstract forms has contributed to drag the work into more dreamy and surreal waters without sacrificing its freshness. Rhode's characters seem calmer, even when they undertake such dynamic activities as shooting pool upside down (*Empty Pockets*, 2008, pp. 106–107), or sitting at the sewing machine and transforming a textile into a brick wall that eventually takes over the whole scene as if it was a living entity (*Brick Face,* 2008, pp. 100–101).

A further confirmation that we are witnessing the next stage in Rhode's art comes from his need to partially distance

himself from it, delegating his performance duties to two doppelgangers. In line with the theatre analogy, the One Man Band artist is now a director and choreographer, and between him and his stage there is now a third party. It is, as a matter of fact, a projection of the artist himself, but it sets a distance that clearly changes his vision.

Most recently, Rhode has had a chance to further investigate the relationship between his work and music theatre. The Lincoln Center in New York has commissioned him to realise the stage design for Leif Ove Andsnes' performance of Modest Mussorgsky's *Pictures at an Exhibition* (1874) in 2009. Initially inspired by the tragic and premature departure of Viktor Hartmann (1834–73), a distinguished artist and architect in 1800s Russia, the musical suite, as the title suggests, is structured as a hypothetical visit to an art exhibition, with the main musical theme, commonly known as a 'promenade', recurring between the ten exhibited 'paintings'.

Fellow artist William Kentridge, in a recent conversation with Rhode about visual art and theatre, remarked how, 'working on projects like [operas] becomes a good excuse – a paid excuse – to investigate a series of things that will have a life beyond.'[5] Rhode's Lincoln Center project, called *Promenade,* is proving to do just this, with offshoots shown as independent works at other venues, for instance, at The Hayward during *Who Saw Who*. Also called *Promenade,* this black-and-white work refers to the passage between segments of Mussorgsky's piano suite, and visualises the structure of the musical piece through a sequence of animated geometric forms that magically interact with a solitary figure (Rhode) at the centre of the scene.

Russian Constructivism has been the inspirational point for Rhode to deal with this subject, and he states:

'I'm totally convinced that geometric is the way forward, especially in regard to my own practice following form rather than content. It's my need to explore mark-making and drawing that has led me towards the Russian Constructivists as well as one of the first Dada films created by Hans Richter titled *Symphonie Diagonale* (1924). My idea for the concerto would be to follow the example of Richter's geometric piece, to create a visual installation that is essential, consisting of geometric abstract forms. Rodchenko becomes Rhodechenko!'[6]

It is the first time that Rhode so openly quotes an artistic model from the past, but there is an interesting symmetry to this. During the first half of the twentieth-century in Europe, experimentation in music and art was moving along parallel tracks. When Expressionist composer Arnold Schoenberg embarked on a trip to explore new sound forms in the 1920s – to the point of creating atonal music and re-discussing fundamental music codes as the seven notes – visual artists were equally busy challenging the conventions of realism and embracing abstract forms. Artists and musicians were associated in this liberating process, and it is perhaps no coincidence that Rhode follows the same route, introducing openly indefinite forms to a practice that until now has always featured a stylised but clean element of realism.

One of Rhode's most recent photographs, *Keys* (2008, p. 103), seems to masterfully connect music and visual art, and it might be the herald of a new stage in Rhode's work. In *Keys*, two hands are leaning on a row of ten white sticks of chalk on a black table. Just as the pianist is about to touch the keys that will start his creation, the artist is about to take the chalks with which he will do the same. The big news is that this time the street element is left out of the equation, but that does not seem to undermine Rhode's work. Quite the opposite, it certifies a more mature approach that does not brush aside those fundamental ingredients that made it special in the first place. Rhode's images are now more minimal and elegant, but they retain the same initial flavour, embedding a vision whose modifications are solely dictated by the artist's genuine personal growth.

Notes

1 Robin Rhode and Thomas Boutoux, in Stephanie Rosenthal (ed.), *Walk Off*, Hatje Cantz, Ostfildern, and Haus der Kunst, Munich, 2007.

2 Ibid.

3 Taj Mahal and Dan Aykroyd, *Elwood's Blues – Interviews with the Blues Legends & Stars*, Backbeat Books, San Francisco, 2004, pp. 82.

4 Robin Rhode and Andrea Bellini, 'The Dimension of Desire', in *Flash Art*, no. 244, October 2005, pp. 92.

5 Robin Rhode and William Kentridge, 'Free Forms', in *Modern Painters*, June 2008, pp. 64.

6 Ibid.

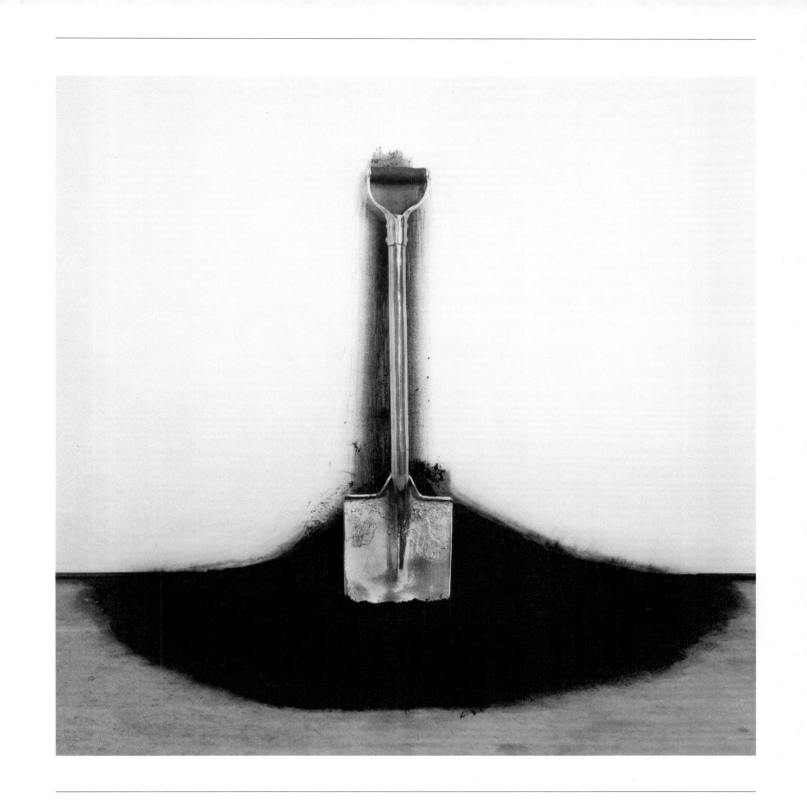

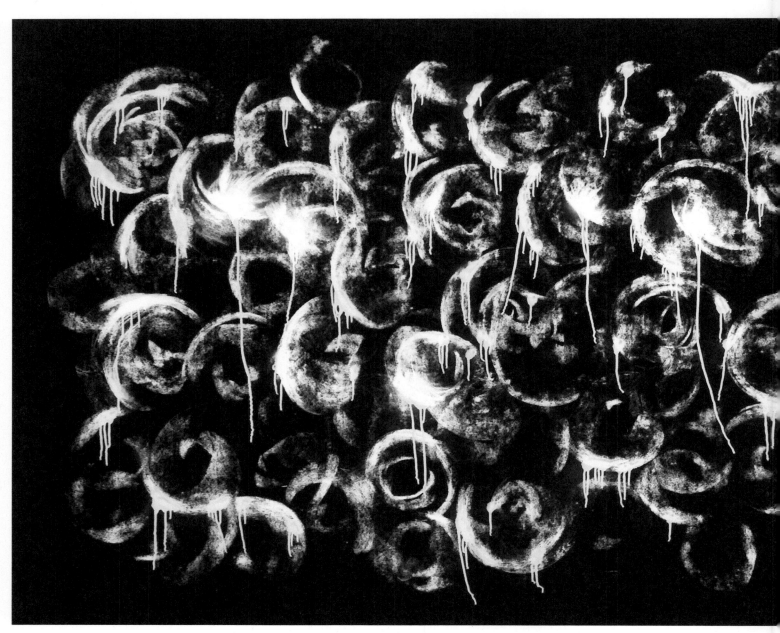

Untitled (Shell Drawing) [2007]

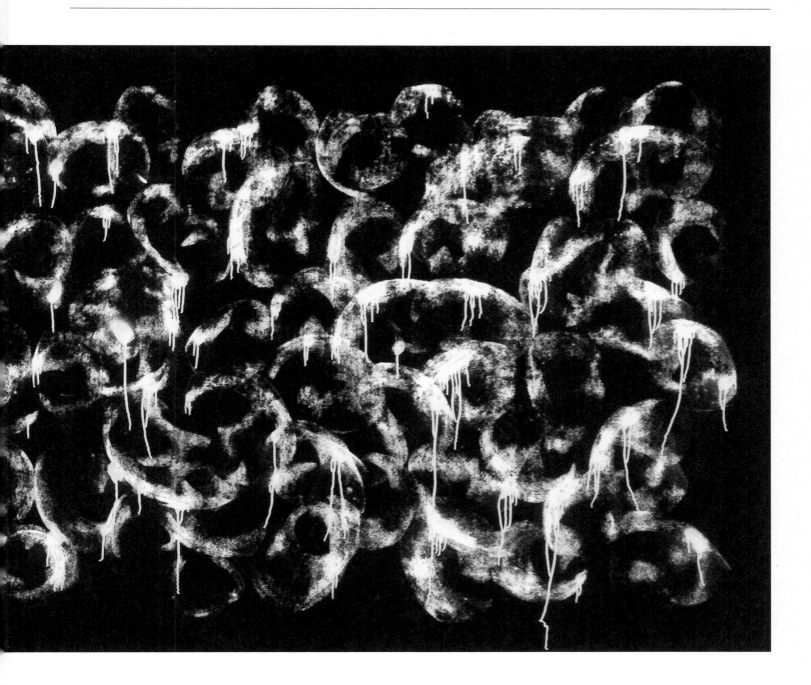

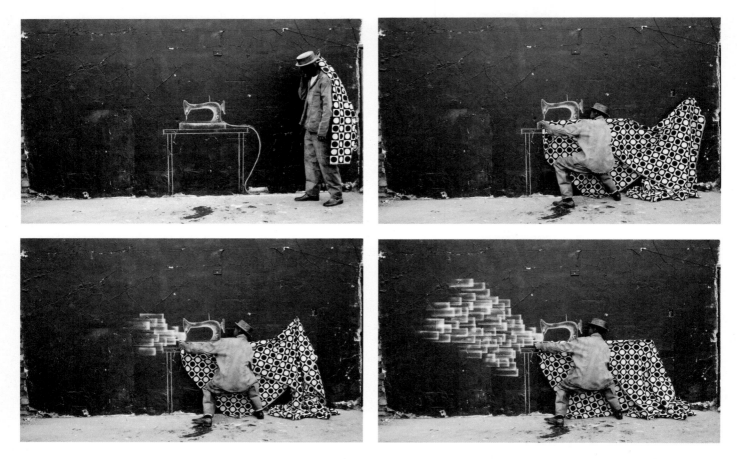

Brick Face [2008]

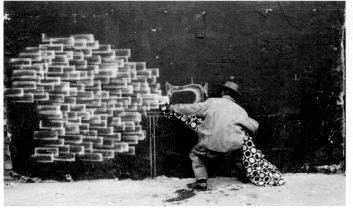
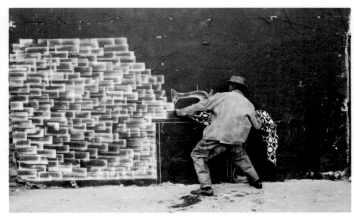
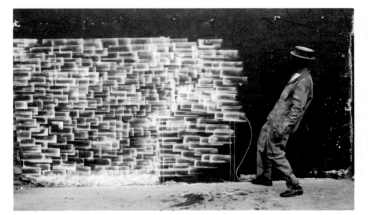

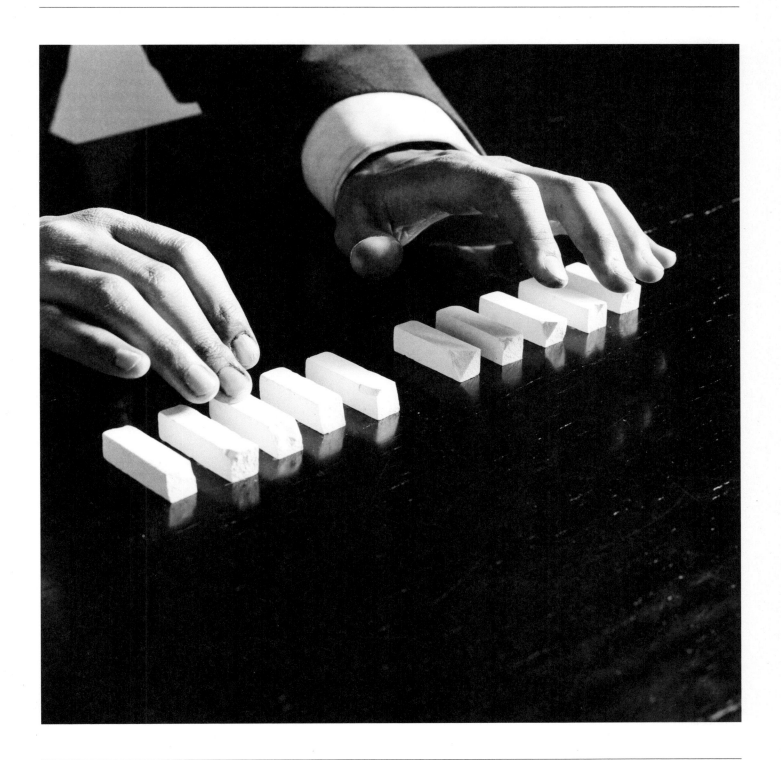

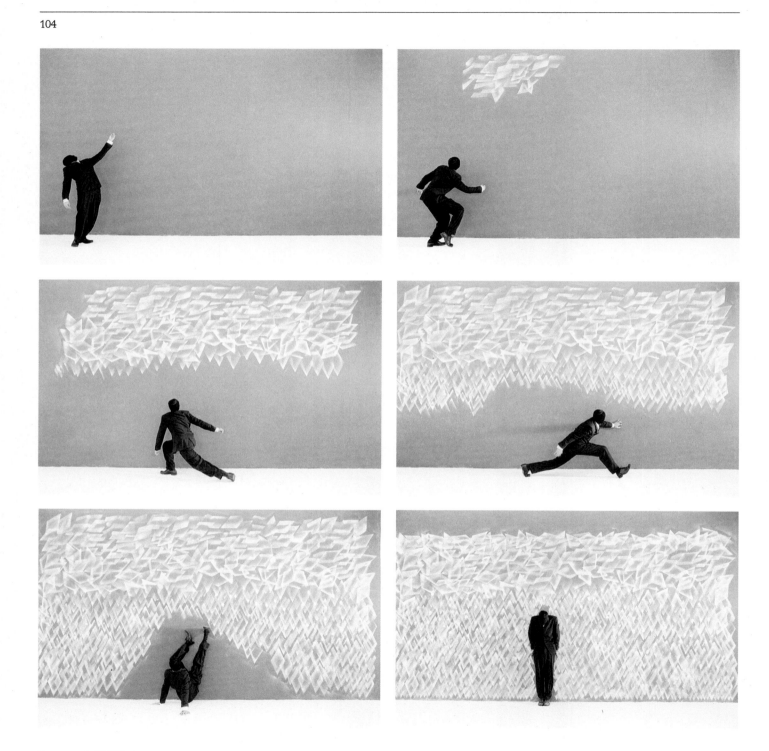

Promenade [2008]

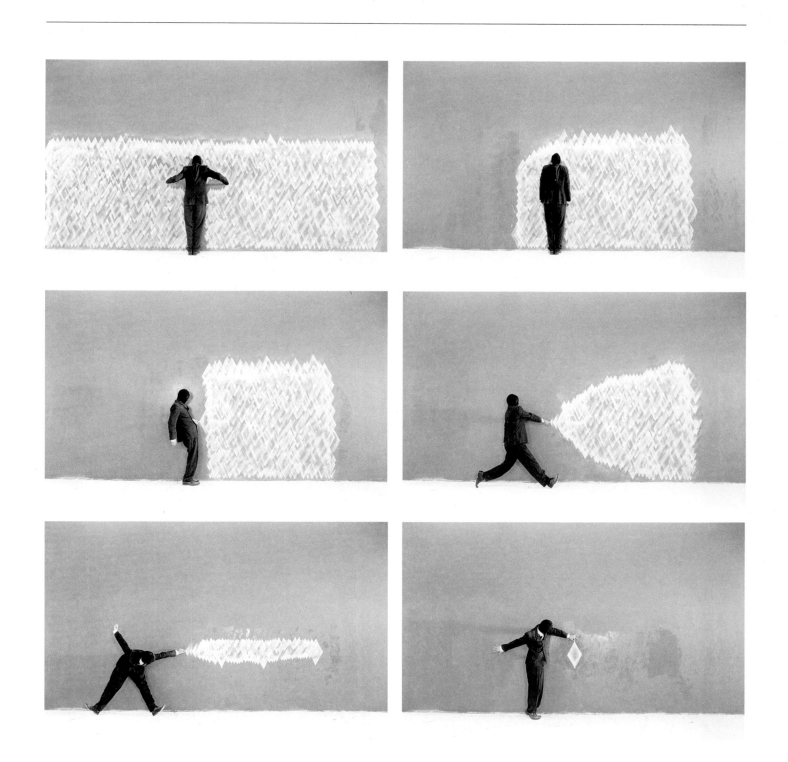

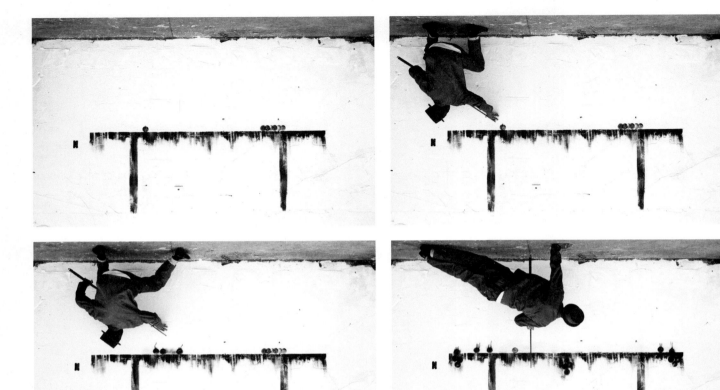

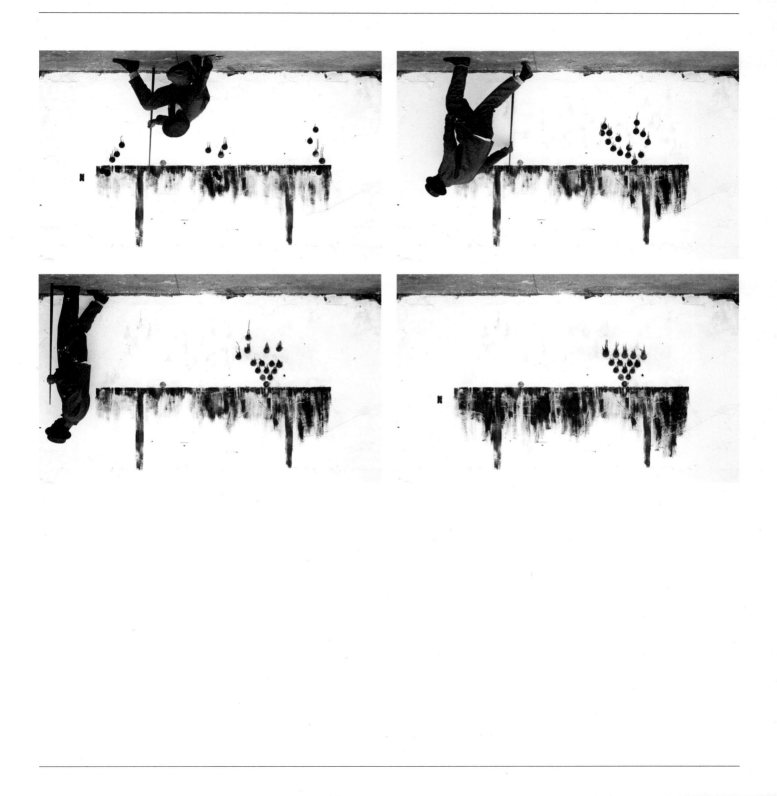

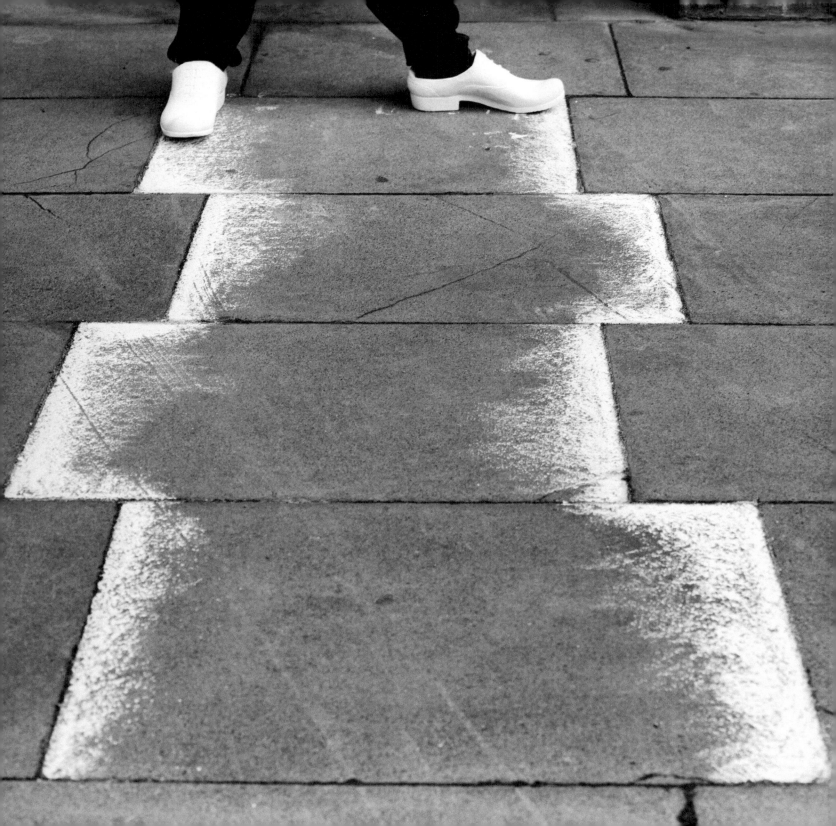

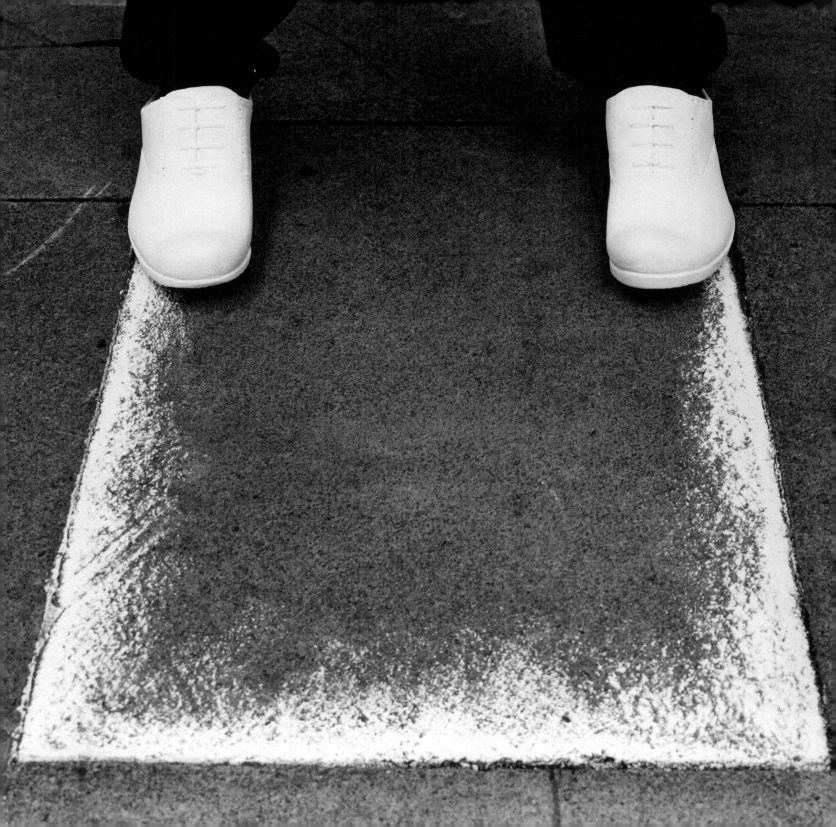

Biography

Robin Rhode
Born in 1976, Cape Town, South Africa
Lives and works in Berlin, Germany

Education

2000
South African School of Film, Television and
Dramatic Arts, Johannesburg, South Africa

1998
Diploma in Fine Art, Witwatersrand Technikon,
Johannesburg, South Africa

Selected Solo Exhibitions

2008
White Cube, London, UK
Robin Rhode: Who Saw Who, The Hayward,
London, UK
Robin Rhode: Promenade, Galleria Tucci Russo,
Turin, Italy

2007
Walk Off, Haus der Kunst, Munich, Germany
Robin Rhode, Perry Rubenstein Gallery,
New York, USA

2006
The Storyteller, carlier | gebauer, Berlin,
Germany
Robin Rhode, Shiseido Gallery, Tokyo, Japan
Robin Rhode, Le Collège / FRAC Champagne-
Ardenne, Reims, France

2005
Street Smart, Rubell Family Collection, Miami,
Florida, USA

2004
Robin Rhode, Perry Rubenstein Gallery,
New York, USA
Busted, New Langton Arts, San Francisco, USA
(with Felipe Dulzaides)
The Score, Artists Space, New York, USA
The Animators, The Rose Art Museum, Brandeis
University, Waltham, Massachusetts, USA

2000
Fresh, South African National Gallery,
Cape Town, South Africa
Living in Public, Market Theatre Galleries,
Johannesburg, South Africa

Selected Group Exhibitions

2008
Prospect.1 New Orleans, New Orleans, USA
*Sensory Overload: Light, Motion, Sound and
the Optical Art Since 1945*, Milwaukee Art
Museum, USA
Stray Alchemists, Ullens Center for
Contemporary Art, Beijing, China
*Street Level: Mark Bradford, William Cordova &
Robin Rhode*, The Institute of Contemporary
Art, Boston, USA; Nasher Museum of
Art at Duke University, Durham, USA;
Contemporary Arts Centre, New Orleans,
USA
*For the Love of the Game: Race and Sport in
African American Art*, Wadsworth Atheneum,
Hartford, USA
Street Art, Street Life, The Bronx Museum of
the Arts, New York, USA

2007
Fantasy – C'est Pas du Jeu!, Centre
Photographique d'Ille-de-France, Pontault-
Combault, France
Animated Painting, San Diego Museum of Art,
USA
An Atlas of Events, Calouste Gulbenkian
Foundation, Lisbon, Portugal
International Contemporary Art from the Harn
Museum Collection, Harn Museum of Art,
Gainesville, USA
Kunstpreis der Böttcherstraße in Bremen 2007,
Kunstalle Bremen, Germany
Cape 07, University of Stellenbosch Gallery,
Cape Town, South Africa
Momentary Momentum: Animated Drawings,
Parasol Unit Foundation for Contemporary
Art, London, UK
*All About Laughter: The Role of Humor in
Contemporary Art*, Mori Art Museum,
Tokyo, Japan

2006
Dirty Yoga: 2006 Taipei Biennial, Taipei Fine Arts
Museum, Taiwan
*Venice-Istanbul: Selections from the 51st
International Venice Biennale*, Istanbul
Museum of Modern Art, Turkey
Version Animée: Animation in Contemporary Art,
Centre pour l'image contemporaine, Geneva,
Switzerland

Street: Behind the Cliché, Witte de With Center for Contemporary Art, Rotterdam, Netherlands
Out of Time: A Contemporary View, The Museum of Modern Art, New York, USA
ars viva 05/06 – Identität/Identity, KW Institute for Contemporary Art, Berlin, Germany
Echigo Tsumari Art Trienniale 2006, Niigata Prefecture, Japan
Human Game. Winners and Losers, Stazione Leopolda, Florence, Italy
Inéditos 2006. Empieza el Juego, La Casa Encendida, Madrid, Spain
The Beautiful Game: Contemporary Art and Fútbol, Brooklyn Institute of Contemporary Art, New York, USA
Dak'Art, Biennale de l'Art Africain Contemporain, Dakar, Senegal
Collection in Context: Gesture, The Studio Museum in Harlem, New York, USA
Contemporary Masterworks: St. Louis Collects, Contemporary Art Museum St. Louis, USA
mima offsite: Animated Drawing, Middlesbrough Institute for Modern Art, UK
Personal Affects: Power & Poetics in Contemporary South African Art, The Contemporary Museum of Honolulu, USA
Biennale Cuvée. World Selection of Contemporary Art, O.K. Center for Contemporary Art, Linz, Austria

2005
Hidden Rhythms, Museum Het Valkhof & Paraplufabriek, Nijmegen, Netherlands
New Photography '05, The Museum of Modern Art, New York, USA
Sounds like Drawing, The Drawing Room, London, UK
S.N.O.W. Sculpture in a Non-Objective Way, Galleria Tucci Russo, Turin, Italy
ars viva 05/06 – Identität/Identity, Kunsthalle, Rostock, Germany
Art Circus, Yokohama Triennial, Yokohama Museum of Art, Japan
Irreducible: Contemporary Short Form Video, Miami Art Central, USA
The Experience of Art, Italian Pavilion, 51st International Art Exhibition: La Biennale di Venezia, Venice, Italy
I Still Believe in Miracles / Drawing Space (part 1), Musée Art Moderne de la Ville de Paris / ARC, Paris, France

Attention à la marche (histoires de gestes), La Galerie, Centre d'art contemporain Noisy-le-Sec, France
Tres Escenarios, Centro Atlántico de Arte Moderno (CAAM), Las Palmas, Gran Canaria, Spain
Upon Further Review; Looking at Sports in Contemporary Art, The Bertha & Karl Leubsdorf Art Gallery, Hunter College, New York, USA

2004
Dedicated to a Proposition, Extra City Center for Contemporary Art, Antwerp, Belgium
Personal Affects: Power and Poetics in Contemporary South African Art, Museum for African Art, Long Island City, USA; The Cathedral of St. John the Divine, New York, USA
Adaptive Behavior, New Museum, New York, USA
MINE(D)FIELDS, Kunsthaus Baselland, Muttenz/ Basel, Switzerland; Stadtgalerie Bern, Switzerland
Tremor – Contemporary South African Art, Palais des Beaux Arts, Charleroi, Belgium
Things you Don't Know 2, Home Gallery, Prague, Czech Republic
Schizorama, National Centre for Contemporary Art (NCAA), Moscow, Russia

2003
Making Space, Platform Garanti Contemporary Art Center, Istanbul, Turkey
How Latitudes Become Forms, Museum of Modern Art Monterrey, Mexico; Museo Tamayo Arte Contemporáneo, Mexico City, Mexico; Walker Art Center, Minneapolis, MN, USA; Fondazione Sandretto Re Rebaudengo, Turin, Italy; Contemporary Arts Museum, Houston, USA
Things You Don't Know 2, Galerie K&S, Berlin, Germany
Coexistence: Contemporary Cultural Production in South Africa, The Rose Art Museum, Brandeis University, Waltham, Massachusetts, USA

2002
Survivre à l'apartheid. De Drum Magazine à Aujourd'hui, Maison Européenne de la Photographie, and Le Studio – Yvon Lambert, Paris, France

Playtime: Video Art and Identity in South Africa, Museum Africa, Johannesburg, South Africa
Dislocation, Image and Identity in South Africa, Sala Rekalde, Bilbao, Spain
Shelf Life, Spike Island, Bristol, UK

2001
Shelf Life, Gasworks, London, UK
FNB Vita Art Prize, NSA Gallery, Durban, South Africa
Tour Guides of the Inner City, Market Theatre Galleries, Johannesburg, South Africa
Switch On/Off, Klein Karoo National Arts Festival, Oudtshoorn, South Africa
Light Sculptures, Klein Karoo National Arts Festival, Oudtshoorn, South Africa
Juncture, The Granary, Cape Town, South Africa; Studio Voltaire, London, UK

2000
Pulse: Open Circuit, NSA Gallery, Durban, South Africa

1999
Babel Tower – 70 South African Artists, Johannesburg Civic Gallery, South Africa
Softserve, South African National Gallery, Cape Town, South Africa
Visions of the Future: The World's Largest Canvas, Johannesburg Civic Gallery, South Africa
Personal Concerns, Market Theatre Galleries, Johannesburg, South Africa
Truth Veils: The Inner City, Market Theatre Galleries, Johannesburg, South Africa
Channel: South African Video Art, Association for Video Art (AVA), Cape Town, South Africa
Unplugged IV, Market Theatre Galleries, Johannesburg, South Africa

1998
Human Rights Day Exhibition, Hillbrow Fort, Johannesburg, South Africa
Technikon Witwatersrand Final Year Exhibition, Market Theatre Galleries, Johannesburg, South Africa

Awards and Residencies

2007
Winner, *illycaffé Prize*, artbrussels 2007,
Brussels, Belgium

2006
Winner, *W South Beach Commission*, Art
Positions at Art Basel Miami Beach 2006,
Miami, USA

2005
ars viva 05/06 – Identität/Identity Award,
Kulturkreis der Deutschen Wirtschaft,
Berlin, Germany

2003
Artist-in-Residence, Walker Art Center,
Minneapolis, USA
Artist-in-Residence, The Rose Art Museum,
Brandeis University, Waltham, Massachusetts,
USA

2001
Artist-in-Residence, Karl Hofer Gesellschaft,
Universität der Künste, Berlin, Germany
Artist-in-Residence, Gasworks, London, UK

2000
Artist-in-Residence, South African National
Gallery, Cape Town, South Africa

Publications

Catalogues and Books

(S) Solo exhibition catalogue
(G) Group exhibition catalogue

2008
Stray Alchemists, Kate Fowle (ed.), Ullens Centre
for Contemporary Art, Beijing. (G)

2007
Walk Off, Stephanie Rosenthal (ed.), Hatje Cantz,
Germany. (S)
*All About Laughter: Humor in Contemporary
Art,* Mami Kataoka (ed.), Mori Art Museum,
Tokyo. (G)
Kunstpreis der Böttcherstraße in Bremen 2007,
Michael Sauer (ed.), Kunsthalle Bremen,
Bremen. (G)
Momentary Momentum: Animated Drawing,
Ziba de Weck Ardalan (ed.), Parasol Unit
Foundation for Contemporary Art,
London. (G)
*Street Level: Mark Bradford, William Cordova,
& Robin Rhode,* Trevor Schoonmaker (ed.),
Nasher Museum of Art at Duke University,
Durham. (G)

2006
Animated Drawing, Judith Winter (ed.), mima:
offsite, Middlesbrough Institute for Modern
Art, Middlesbrough. (G)
Mónica Ashida, *Casa Del Lago Juan José Arreola:
Memoria de Exposiciones '06,* Mexico City. (G)
*Biennale Cuvée: World Selection of Contemporary
Art,* Ingrid Fischer-Schreiber (ed.), O.K.
Center for Contemporary Art, Linz. (G)
Contemporary Masterworks: St. Louis Collects,
Paul Ha (ed.), St. Louis Art Museum,
St. Louis. (G)
*Das Schicksal des Paradieses liegt in seiner
Geometrie,* Philippa Walz (ed.), Kunstverein,
KISS Kunst im Schloss Untergröningen e.V.
Abtsgmünd-Untergröningen. (G)
Dirty Yoga: 2006 Taipei Biennial, S. Yu and
F. Chou (eds), Taipei Fine Arts Museum,
Taipei. (G)
Inéditos 2006, Obra Social Caja Madrid (ed.),
La Casa Encendida, Madrid. (G)

Human Game: Winners and Losers, Francesco
Bonami, Maria Luisa Frisa and Stefano Tonchi
(eds), Fondazione Pitti Discovery, Florence. (G)
Street: Behind the Cliché, Nicolaus Schafhausen
(ed.), Witte de With Center for Contemporary
Art, Rotterdam. (G)
Robin Rhode, T. Okamura (ed.), Shiseido Gallery,
Tokyo. (S)
*Robin Rhode: The Storyteller, une légende
d'automne,* G. Ménou (ed.), Le Collège / Frac
Champagne-Ardenne, Reims, published in
the series: *Editions Analogues,* Semaine 08.06,
no. 84, Arles. (S)
*Venice-Istanbul: A Selection from the 51st
International Venice Biennale,* Cem Ileri (ed.),
Istanbul Museum of Modern Art, Istanbul. (G)

2005
ars viva 05/06 –Identität / Identity, Kulturkreis
der deutschen Wirtschaft im BDI e.V,
Kunsthalle Rostock; Extra City – Center for
Contemporary Art, Antwerp; and
KW Institute for Contemporary Art, Berlin.
Frankfurt am Main. (G)
Attention à la marche (histoires de gestes),
Julie Pellegrin (ed.), La Galerie, Centre d'art
contemporain, Noisy-le-Sec. (G)
J.T. Demos, *Vitamin Ph,* Phaidon Press, New York
and London. (G)
Hidden Rhythms, Hilde De Brujin (ed.), Museum
Het Valkhof & Paraplufabriek, Nijmegen. (G)
Jens Hoffmann and Joan Jonas, *Art Works:
Aktion,* Hildesheim.
S.N.O.W. Sculpture in Non-Objective Way,
hopefulmonster (ed.), Galleria Tucci Russo,
Turin. (G)
Tres scenarios, Elvira Dyangani (ed.), Centro
Atlántico de Arte Moderno, Gran Canaria. (G)

2004
Adaptive Behavior, Yukie Kamiya (ed.),
New Museum, New York. (G)
*Personal Affects: Power and Poetics in
Contemporary African Art,* 2 Vols, Sophie
Perryer (ed.), Museum for African Art,
Long Island City, New York. (G)
Tremor: Contemporary South African Art,
Emma Bedford (ed.), Palais des Beaux Arts,
Charleroi, Brussels. (G)

2003

How Latitudes Become Forms, Philippe Vergne (ed.), Walker Art Center, Minneapolis. (G)
Things You Don't Know, Karel Cisar (ed.), K&S Gallery, Berlin. (G)

2001

Fresh. Robin Rhode, Emma Bedford (ed.), South African National Gallery, Cape Town. (S)

Selected Articles

2008

William Kentridge in conversation with Robin Rhode, 'Free Forms', in *Modern Painters,* June 2008, pp. 64–69.
'Robin Rhode – Promenade', in *Like you – The Artnetwork,* 8 May 2008, http://www.likeyou.com/en/node/1161 (accessed 10 June, 2008).
Tracey Samuelson, 'Robin Rhode', in *Lost at E Minor,* 23 April 2008, http://www.lostateminor.com/2008/04/23/robin-rhode/ (accessed 10 June 2008).
Aspasia Karras, 'Framed – Robin Rhode', in *The Times,* 17 March 2008, p. 25.

2007

Benjamin Genocchio, 'Robin Rhode', in *The New York Times,* 8 June 2007, p. E27.
Sue Williamson, 'Robin Rhode at Perry Rubenstein', in *ARTTRHOB,* 8 June 2007, http://www.artthrob.co.za/07jun/reviews/perry.html.
Anne Stringfield, 'Robin Rhode', in *The New Yorker,* 4 June 2007, p. 17.
Carol Kino, 'Something There Is That Loves a Wall', in *The New York Times,* 13 May 2007, p. AR24.
Miguel Amado, 'Street Level', in *Artforum.com,* Critic's Picks, May 2007, http://artforum.com/archive/id=15286 (accessed 4 June 2007).
Francois Quintin, 'Robin Rhode', in *UOVO #13: Colour Spectrum,* April 2007, pp. 114–147.
Lucy Birmingham Fujii, 'Funny and Dark, the Mori Laughs', in *The Japan Times,* 8 February 2007, p. 17.

2006

Melvyn Minaar, 'SA Artist's Work a Knock-out at International Miami Fair', in *Cape Times,* 14 December 2006.
Christina Ruiz, 'Punching Well Above His Weight', in *The Art Newspaper,* Art Basel/Miami Beach Daily Edition, 7 December 2006, p. 2.
Ignacio Villarreal Jr., 'Art Basel Miami Beach-Art Perform', in *ArtDaily.org,* 8 November 2006, http://artdaily.com/indexv5.asp?int_sec=2&int_new=18065 (accessed 10 June 2008).
Claire Tancons, 'One to Watch: Robin Rhode', in *ArtKrush,* 3 May 2006, http://beta.artkrush.com/12194 (accessed 10 June 2008).

Philip Auslander, 'Straight Out of Cape Town', in *Art Papers,* March/April 2006, pp. 17–19.
Filipp Bakhtin, 'Sport: Street Games', in *Esquire Magazine* (Russia), January 2006, p. 234.

2005

Andrea Bellini, 'Robin Rhode: The Dimension of Desire', in *Flash Art,* 244, October 2005, pp. 90–93.
Lauri Firstenberg, 'Robin Rhode', in *Contemporary 21,* no. 74, September 2005, pp. 86–89.
Sean O'Toole, 'At the Centre's Edge', in *Art South Africa,* 1, no. 4, Spring 2005, pp. 24–29.
Grace Glueck, 'The Listings', in *The New York Times,* 11 February 2005, p. E28.
Faye Hirsch, 'Subjective State: Recently on View in New York, a Two-Venue Exhibition of Contemporary Art from South Africa Conveyed a Refreshing Cultural Openness 10 Years After the Demise of Apartheid', in *Art in America,* February 2005, p. 131.
Sean O'Toole, 'Robin Rhode at Perry Rubenstein', in *Art in America,* February 2005, p. 131.
Megan Ratner, 'Robin Rhode', in *Frieze,* 88, January/February 2005, pp. 120–121.
Jonathan Turner, 'Review: Robin Rhode at Perry Rubenstein Gallery', in *ARTnews,* January 2005, pp. 123–124.

2004

Roselee Goldberg, 'Robin Rhode: New Museum of Contemporary Art / Perry Rubenstein Gallery / Museum for African Art', in *Artforum,* December 2004, pp. 196–197.
Roberta Smith, 'Art in Review', in *The New York Times,* 29 October 2004, p. E38.
Laurie Ann Farrell, 'At the Centre's Edge', in *Art South Africa,* 4, Issue 1, Spring 2004, p. 68.
Ivan Mecl, 'Street Animation', in *Umelec,* 2, Summer 2004, pp. 78–79.

2003

Ruth Kerkham, 'Coexistence: Contemporary Cultural Production in South Africa', in *NKA Journal,* Spring/Summer 2003, pp. 92–93.
Claire Tancons, 'Fugitive: Robin Rhode Drawings and Performances', in *NKA Journal,* Spring/Summer 2003, pp. 66–71.

Collections

Works by Robin Rhode are included in the following collections:

BHP Billiton South African Art Collection, Johannesburg
Collection Frac Champagne-Ardenne, Reims
Collection Martin Z. Margulies, Miami
Collection of Beth Rudin DeWoody, Palm Beach, Florida
Collection of Donald J. Bryant Jr., New York
Collection of Eileen Harris Norton, Santa Monica, California
Collection of Matthew Fitzmaurice, Minneapolis
Collection of Robert Devereux and Vanessa Branson, London
Collection of the Hirshhorn Museum and Sculpture Garden, Smithsonian Institute, Washington DC
Ebrahim Melamed, Honart Museum Collection, Tehran
General Mills Art Collection, Minneapolis
Goetz Collection, Munich
gordonschachatcollection, Johannesburg
Hall Collection, Southport, Connecticut
Johannesburg Art Gallery, Johannesburg
Julia Stoschek Collection, Dusseldorf
Lauren and Benedikt Taschen Collection
Marieluise Hessel Collection, Hessel Museum of Art, Center for Curatorial Studies, Bard College, Annandale-on-Hudson, New York
Michael and Fiona King, London
Milwaukee Art Museum, Milwaukee, Wisconsin
Mr. and Mrs. Irving Blum, Los Angeles
MTV Networks, New York
Musée d'Art Moderne de la Ville de Paris, Paris
Nasher Museum of Art at Duke University, Durham, North Carolina
Orange County Museum of Art, Orange County, California
Rubell Family Collection, Miami
Shawn Carter Collection, New York
Solomon R. Guggenheim Museum, New York
South African National Gallery, Cape Town
Steven A. Cohen Collection, Stanford, Connecticut
The Chaney Family Art Collection, Houston
The Dakis Joannou Collection, Athens
The Ella Fontanals Cisneros Collection, Miami
The Museum of Modern Art (MOMA), New York
The Ninah and Michael Lynne Collection, New York
The Rose Art Museum of Brandeis University, Waltham, Massachusetts
The Sender Collection, New York
The Studio Museum in Harlem, New York
Walker Art Center, Minneapolis

List of Works

All measurements are in centimetres, height × width × depth. Not all works are illustrated in their entirety.

All works are courtesy Perry Rubenstein Gallery, New York, unless stated otherwise. All images are courtesy the artist and Perry Rubenstein Gallery, New York, unless stated otherwise.

pp. 28–29
New Kids on the Bike, 2002
Digital animation
1:21 mins

pp. 30–31
White Walls, 2002
28 C-prints
23.5 × 30.16
Collection of Matthew Fitzmaurice, Minneapolis

pp. 32–33
Catch Air, 2003
12 C-prints
26 × 34.3 each

pp. 42–43
Color Chart, 2004–06
Digital animation
4:50 mins

pp. 34–35
Gun Drawings, 2004
Set of 8 drawings
Charcoal on paper
69.9 × 100.3 each
Collection of Matthew Fitzmaurice, Minneapolis

pp. 36–37
Night Caller, 2004
10 digital C-prints
30.5 × 45.7 each

pp. 40–41
Stone Flag, 2004
9 C-prints
30.6 x 45.8 each

pp. 38–39
The Stripper, 2004
Digital animation
2:22 mins

pp. 58–59
Untitled (Anchor), 2005
9 C-prints
30.5 × 45.7 each

pp. 60–61
Untitled (Hard Rain), 2005
16 C-prints
45.7 × 30.5 each
Collection of Perry Rubenstein, New York

pp. 62–63
Untitled (Landing), 2005
20 C-prints
30.5 × 45.7 each
Hall Collection, New York

pp. 64–65
Untitled (Yo Yo), 2005
15 C-prints
30.5 × 45.7 each
Private collection, Michael and Fiona King, London

pp. 66–67
Blackhead, 2006
16 digital pigment prints
39.4 × 55.9 each
Collection of Perry Rubenstein, New York

pp. 68–69
Wheel of Steel, 2006
9 gelatin silver prints
39.4 × 55.9 each
Shawn Carter Collection, New York

p. 71
Black Fist, 2007
Black and white fibre print
118.1 × 78.7
Private collection
Courtesy White Cube, London

pp. 72–73
Candle, 2007
16mm black-and-white film
2:13 mins

pp. 74–75
Cap n' Coins, 2007
Silver plated bronze, steel, coins
9 × 24 × 21
Collection of Perry Rubenstein, New York

pp. 76–77
Juggla, 2007
20 digital pigment prints
53.3 × 35.6 each
Private collection
Courtesy White Cube, London

pp. 78–79
Rough Cut, 2007
12 digital pigment prints
35.6 × 53.3 each
Sender Collection, New York

p. 81
Soap and Water, 2007
Soap, steel, bronze, water
Bicycle: 188 × 114 × 64
Bucket: 30 × 33 × 30

p. 97
Spade, 2007
Gold plated bronze and charcoal
88 × 21 × 9
Courtesy Goetz Collection, Munich

pp. 98–99
Untitled (Shell Drawing), 2007
Chalk and spray paint on black paper
147.3 × 358.1

pp. 4, 94, 95 (details)
Stone Drawings, 2007–08
Set of 8
Charcoal dust on grey cardboard paper
100 × 190; 100 × 152; 100 × 105; 100 × 98;
100 × 105; 100 × 65; 100 × 210; 100 × 102

pp. 100–101
Brick Face, 2008
20 digital pigment prints
66 × 101.5 each (printed large scale for The Hayward exhibition)
Collection of Perry Rubenstein, New York

pp. 106–107
Empty Pockets, 2008
21 digital C-prints
40.6 × 63.5 each

p. 103
Keys, 2008 (previously known as *Untitled (Promenade)*)
Black-and-white pigment print
120 × 120

Kite, 2008
HD video projection, cotton strings, C-print on
archival rag paper
112 × 152.5

pp. 104–105
Promenade, 2008
Digital HD animation
Approximately 5 mins

p. 109
St. Bernard's Parish, 2008
Digital pigment print
76.2 × 114.3

Untitled (Black Painting), 2008
Oil and spray paint on paper
140 × 130

pp. 6–7, 26, 27 (details)
Mixed Media Drawings, 2008
Set of 2
Oil stick, spray paint and charcoal on grey
cardboard paper
100 × 174 (*Untitled / White drawing*)
100 × 153 (*Untitled / Black drawing*)

Documentation of Performances
DVD
2005: *Untitled (Skipping Rope)* (*I Still Believe in
Miracles / Drawing Space (part 1)*, Musée Art
Moderne de la Ville de Paris / ARC, Paris, France)
2004: *Pulling Loads* (*How Latitudes Become
Forms*, Museo Tamayo Arte Contemporáneo,
Mexico City, Mexico; *Night Caller* (*Robin Rhode*,
Perry Rubenstein Gallery, New York, USA);
Untitled (Exit/Entry) (*How Latitudes Become
Forms*, Contemporary Arts Museum, Houston,
USA); *The Score* (*The Score*, Artists Space,
New York, USA)
2003: *Untitled* (*How Latitudes Become Forms*,
Fondazione Sandretto Re Rebaudengo, Turin,
Italy); *Car Theft, Car Wash* (*How Latitudes
Become Forms*, Walker Art Center, Minneapolis,
USA)
2001: *Motorbike* (*Shelf Life*, Gasworks, London,
UK)

List of Comparative Illustrations

All measurements are in centimetres,
height × width × depth.

All images are courtesy the artist and Perry
Rubenstein Gallery, New York, unless
stated otherwise.

pp. 1, 12, 13, 44, 45, 56, 57, 82, 83, 110, 111, 120
Untitled (Hayward series), 2008

p. 19
He Got Game, 2000
12 C-prints
22.9 × 29.8 each

p. 20
Frequency, 2007
Performance
Haus der Kunst, Germany
Courtesy of the artist and Haus der Kunst,
Munich

p. 23
Monument to the Chairman, 2008
25 digital pigment prints
45.7 × 70.5 each panel

p. 24
Night Boarding, 2004
6 gelatin silver prints
40 × 26.7 each

p. 47
Untitled, 2003
Performance video still
Fondazione Sandretto Re Rebaudengo, Turin

p. 50
*Artist's Impression (Queen Elizabeth Hall
undercroft)*, 2008

p. 55
Untitled (Skipping Rope), 2005
Performance video still
Musée Art Moderne de la Ville de Paris, Paris

p. 85
Untitled (Dream Houses), 2005
28 C-prints
31 × 46 each

p. 86
Snake Eyes, 2004
Gelatin silver prints
26.7 × 40

p. 89
The Score, 2004
Performance video still
Artist's Space, New York

Published on the occasion of the exhibition *Robin Rhode: Who Saw Who*, The Hayward, London, UK, 7 October – 7 December 2008

Exhibition curated by Stephanie Rosenthal
Exhibition organised by Chelsea Fitzgerald and Dana Andrew

Art Publisher: Caroline Wetherilt
Publishing Co-ordinator: Giselle Osborne
Sales Manager: Deborah Power
Catalogue designed by hoopdesign.co.uk
Printed in Italy with thanks to F&G

Front and back cover: *Untitled (Hayward Series)*, 2008

Published by Hayward Publishing, Southbank Centre, Belvedere Road, London, SE1 8XX, UK
www.southbankcentre.co.uk
© The Hayward / Southbank Centre 2008
Texts © the authors 2008
Artworks © Robin Rhode 2008
All images are courtesy the artist and Perry Rubenstein Gallery, New York, unless stated otherwise

Hayward Publishing would like to thank Perry Rubenstein Gallery, New York, and White Cube, London, for their generous support of this catalogue.

ISBN 978 1 85332 271 6

Distributed in North America, Central America and South America through D.A.P. / Distributed Art Publishers, 155 Sixth Avenue, 2nd Floor, New York, N.Y. 10013
tel: +212 627 1999, fax: +212 627 9484
www.artbook.com

Distributed outside North and South America by Cornerhouse Publications, 70 Oxford Street, Manchester M1 5NH,
tel: +44 (0)161 200 1503; fax: +44 (0)161 200 1504
www.cornerhouse.org/books

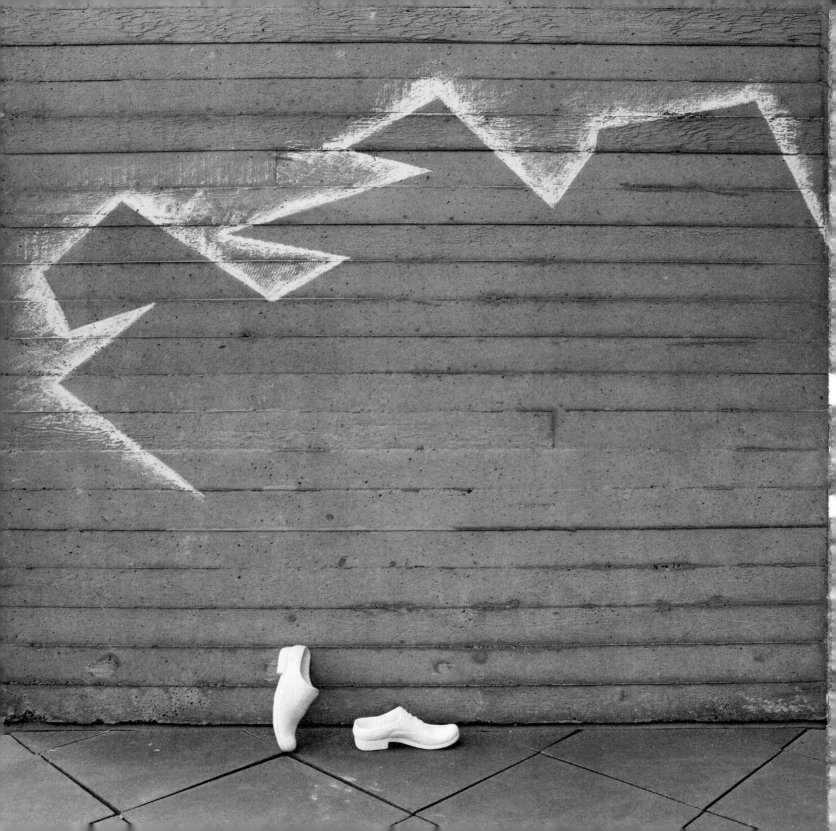